Arthur L. Guptill / Editor: Catherine Sullivan

color

manual

for artists

VNR VAN NOSTRAND REINHOLD COMPANY
NEW YORK CINCINNATI TORONTO LONDON MELBOURNE

Paper edition published in 1980 by Van Nostrand Reinhold Company
A division of Litton Educational Publishing, Inc.
135 West 50th Street, New York, N.Y. 10020, U.S.A.

Van Nostrand Reinhold Limited
1420 Birchmount Road, Scarborough, Ontario M1P 2E7, Canada

Van Nostrand Reinhold Australia Pty. Limited
178 Queen Street, Mitcham, Victoria 3132, Australia

Van Nostrand Reinhold Company Limited
Molly Millars Lane, Wokingham, Berkshire, England

16 15 14 13 12 11 10 9 8 7 6 5 4 3

Contents

Editor's Note 5

1. Color Facts and Color Theories 7

2. The Qualities of Color and Their Measurement 20

3. Color as Pigment 24

Color Plates 33

4. Watercolor—Equipment and Basic Techniques 50

5. Oil—Equipment and Basic Techniques 63

6. Getting to Know Your Pigments 75

7. Making and Using Color Charts 88

8. Color Illusions—Visual Phenomena 97

9. Color Harmony 109

10. The Aesthetic Instinct 122

Bibliography 125

Editor's Note

For many years Arthur L. Guptill's *Color in Sketching and Rendering* has been a standard guide for the artist seeking to enlarge his knowledge of color and his ability to use it effectively. The volume has been out of print since 1955 after numerous reprintings. Continued interest in it impelled the publisher to plan this new book.

In the present volume, the material on color has been brought up-to-date and expanded to include the medium of oil as well as watercolor. Chapters on sketching and architectural rendering have been dropped so that throughout the book the focus is on color in painting.

Changes in format and new material have necessitated the use of additional illustrations, but the original drawings and charts have been used wherever feasible. Revisions and additions are, for the most part, drawn from Arthur Guptill's own work — his articles in *American Artist* magazine and his later books on oil painting and watercolor technique. In the sections which are wholly new, such as those dealing with color as pigment and the most recent developments in color science, Mr. Guptill's over-all approach has been kept in mind. My close association with Mr. Guptill over a number of years at Watson-Guptill Publications and *American Artist* magazine has helped me in this undertaking.

We have tried to make this book a useful up-to-date handbook on color, but in spirit not very different from Arthur Guptill's original. We hope — and believe — he would have approved.

Catherine Sullivan

Color Facts and Color Theories

Color is so constantly in evidence in our daily lives that we are inclined to give it almost no conscious attention. We merely accept color, as we do sunshine and shadow, failing not so much in our appreciation of its beauty — for we all like color — as in a full realization of what an important part it plays in our daily lives. Color to many of us is a thing to admire consciously or openly only now and then, when particularly called to our attention, as in a sunset or a striking painting. Actually, however, even though we do not realize it, color influences us during practically every waking moment.

For, although color in itself is not absolutely essential to human life, as is shown by the fact that the achromatic vision of the totally color-blind person apparently meets his needs fairly well, it is still true that our ability to see color all about us adds inestimably to the richness of our existence. There is, undoubtedly, a growing recognition of the important part which color plays in almost every branch of our emotional and spiritual lives. We are more inclined to cheerfulness on bright, colorful days than when the sky is gray. We are more contented in harmoniously colored rooms of reasonably distinct hue than in those which are drab; on the contrary, we are disturbed by interiors which are gaudy and crude. We admire clothes of beautiful color and like to have colorful things about us such as books, flowers and pictures. We like the out-of-doors for its green trees, blue skies and purple hills. Even our food is more appetizing when it is attractive in color than when it is neutral in tone. As color affects our happiness, it in turn affects our health, so its effects are far reaching.

Not the least of its merits is that color serves us in many practical ways. It aids us, for instance, in distinguishing one object from another at a glance, as is illustrated when we go to the bookcase to select

some familiar volume. It helps us to know whether fruits or vegetables are unripe, ripe or spoiled; whether food is raw, sufficiently cooked or overdone; whether objects are extremely hot or cold. It guides us in judging many conditions of sickness and health. It aids us in determining comparative distances. A moment's contemplation brings to mind numerous ways in which color serves us. There is scarcely a phase of existence not affected by color in some way.

Color becomes so much a part of us, despite our customary lack of conscious appreciation of it, that should we suddenly become unable to distinguish one hue from another, we would immediately realize our deep loss. The world would offer, instead of its accustomed harmony of many colors, much the neutrality of a black-and-white photograph. It would be a gray world indeed, both figuratively and literally.

Just as color interests and pleases us today, so it apparently affected primitive man. At least, we have ample evidence of the constant use of pigments from the earliest known times. Not only was the humble home, together with its implements and utensils, embellished in gorgeous hues, but its inhabitants employed colors lavishly both on their clothing and their bodies. The male of the species, contrary to our present custom, went forth, especially when in battle array, dressed, accoutred and adorned in the most vivid colorings imaginable, doubtless to his own great delight, and supposedly to the consternation of his enemy.

If from this early starting point we should trace the gradual progress of mankind, we would find this same love of color manifesting itself over and over again. At the time of the ancient Egyptians, Persians and Assyrians, for instance, color was still used in abundance, yet with an increased restraint and appreciation consistent with the development of civilization as a whole.

From those days of thousands of years ago to the present, color has continued to occupy the attention of man, who has ever sought to wrest its secrets from nature. With the advance of science, the speculation of the ancient has given way to the intelligent research and experimentation of the trained investigator. Especially during the last century or two have physicists, physiologists, and more recently, psychologists studied the problems of light and color and the processes of vision. Nor have the chemists been idle in the meanwhile, for under them a sound advance has been made in the discovery and perfection of pigments. The colorists in various fields have done their part by putting these pigments to all sorts of uses, seeking at the same time laws regarding their harmonious application.

In view of the united efforts of so many serious investigators over so long a period of time, the student entering upon any phase of color study usually expects to find the

entire subject thoroughly understood and placed on a truly scientific basis, with exact laws determined, perhaps comparable to those of music. It is often a great surprise for him to learn that, although marked progress has been made in every department of color investigation, nature still withholds many of its secrets. In fact, years may yet elapse before light itself and color vision, which permits us to see colors all about us (for color is only a matter of vision, as we shall explain more fully a bit later), are thoroughly understood. Man, too, despite any claims to the contrary, progresses slowly in his attempts to discover definite and infallible laws regarding the concordant employment of color in such pigment forms as paints, inks and dyes. It is more than possible that such laws may never be found.

When the student first comes to a full realization of the fact that the employment of color is not a thing which he can learn to any great extent by rule — that there are few precise and easily applied laws for his guidance — he is quite sure to wonder just how he will manage to make satisfactory progress.

A bit later we plan to offer a word of advice as to what course he should follow. Enough now to assure him that, despite this condition that seems in certain aspects a bit puzzling or chaotic (or will, at any rate, by the time the next few pages have been read), his path will by no means be as difficult as he might expect. As a

preliminary to this advice, we now propose to present a short discussion designed to give him the background necessary for any serious approach to color study.

To Sir Isaac Newton, working in the 17th century, is attributed the discovery that light consists of many rays, each of which, when allowed to impinge separately upon the retina of the human eye, produces the sensation of a distinct color, the fusion of all the sensations generated by the mixture of rays giving the sensation of white. Color, therefore, was shown to be a sensation — a matter of vision.

Until Newton's time it was commonly believed that color was as much an inherent characteristic or property of any object as was its shape or texture. It is not easy for us, even now, to realize fully the established fact that the red of an apple is not an innate quality of the apple, strictly speaking, but that we merely *see* an apple as red because it has the property of absorbing some rays of light while reflecting others to the eye — a matter to which we shall presently return.

Light and color are essentially one, so the student who cares to make anything approaching a complete investigation of color should lay a foundation by grounding himself thoroughly in a knowledge of both the physical facts concerning light and the physiological and psychological effects of light, and its resultant color, on the individual. He can best do

this by turning to some of the recognized books on the subject. One of the best we have come across is Ralph M. Evans' *An Introduction to Color* (John Wiley & Sons) which seems to cover the subject pretty thoroughly in regard to physics, physiology and psychology and also includes chapters on paints and pigments, and color in art, design and photography. The Optical Society of America has also produced an excellent volume on the various scientific aspects of color called *The Science of Color* (Thomas Y. Crowell). Although most of the material in this book is in the language of the scientist, there are two very helpful introductory chapters for the nonexpert.

In view of the availability of these and other such books for those who may wish to investigate this phase of color study more thoroughly, we shall offer here only a few fundamental facts, stated so far as possible in non-technical terms.

Light is said to come from its source as a wave motion, the waves traveling at the remarkable speed of approximately 186,000 miles a second. The sensation known as color is produced by the action of these waves of light upon the human eye. The waves vary in length; these variations in wave length produce different sensations in the eye corresponding to the different hues with which we are familiar.

Newton performed a most interesting experiment in this connection which anyone can easily repeat. In a darkened room he admitted a beam of sunlight through a slit in a window shade and allowed it to traverse a prism. This separated or decomposed the light into a long line of colors, imperceptibly graded one into another, similar to a rainbow. This separation of white light into its elements is called dispersion. The resulting band is known as the spectrum. The colors of the spectrum arrange themselves in the order of their wave lengths, the long waves being less refracted (that is, bent as they pass through the prism) than the short. Starting with the red, which has the longest and slowest vibrating waves of any color visible to the human eye, innumerable colors follow, the most prominent being, in this order, red, orange, yellow, green, blue, indigo and, finally, violet, which, has the shortest and most rapid waves of any visible color. This experiment of Newton's is illustrated in Figure 1.

These light waves which are visible to the person of normal eyesight constitute but a small proportion of all the light rays which exist. We are color-blind to waves longer than about 0.0007 millimeters (the approximate length of red rays) or shorter than about 0.0004 millimeters (the approximate length of violet rays), many others, including the infrared and ultraviolet, being invisible under customary conditions.

Newton followed his experiment of separating white light into the pris-

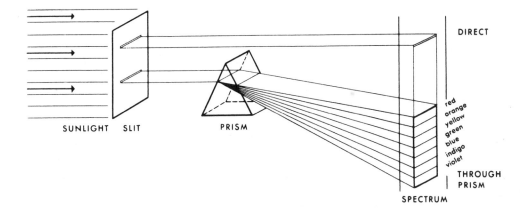

Figure 1. This diagram of Isaac Newton's experiment shows how a beam of white light, passed through a prism, is refracted and broken up into the colors of the spectrum.

matic spectrum by a second, in which he passed a portion of this colored band through an aperture in another screen, permitting it to traverse a second prism. As he found no additional change of color he was convinced that monochromatic light could be no further decomposed.

Newton also demonstrated that not only can white light be decomposed into many colors by a prism (such experiments are often carried out today with the spectroscope or similar apparatus), but that these colors can be recombined into white light. This can be proved by impressing such colors on a second prism, or by receiving them from the original prism onto mirrors or lenses so curved as to convey all to a single spot where they will reunite to form white.

Thus, it was long ago shown beyond reasonable doubt that light is the source of color, and that white light, which seems so simple and pure, is, in reality, made up of varying rays, each capable of producing the sensation of a distinct hue. It is obvious, then, that when light is present, color is present; when light is absent, color is absent. It follows, too, that the nature of light influences the nature of color; objects look different under daylight, incandescent light, fluorescent light, colored light, etc. In experiments such as we have mentioned, the light from the sun is usually considered as white; actually, as it reaches us through the

atmosphere, it is often far from pure.

With this as a background, let us consider why one object looks red and another green. If we glance at a given object (excepting self-luminous, fluorescent or transparent ones which would bring us into a discussion more involved than we need enter here), we are able to see it by the light cast upon it and reflected to the eye. It is easy to understand that, if the object is in strong light, it reflects much light and therefore appears bright; if in dim light, it reflects little and seems indistinct. It is not so easy to understand why one object appears red and another green until we learn that surfaces exercise a selective power on the light of the sun or other source of illumination, every surface decomposing the particular light with which it is illuminated, absorbing some of the constituent rays while reflecting or scattering others in all directions. (We are here refraining from any consideration of the different kinds of reflection and reflective surfaces, and from a discussion of the appearance of objects exposed to colored light.)

A red book, as it decomposes the light which falls upon it, absorbs or annihilates all the rays but the red; these are reflected, some of them reaching the eye, which instantly conveys to the brain, via the optic nerve, the sensation of red. A green book, on the contrary, has the power of absorbing all the rays but the green; these are the ones reflected.

A white object is merely one which reflects a large percentage of the rays, including all colors so balanced as to give the effect of absence of color — white. A black object is one which absorbs nearly all the rays which reach it. A gray object absorbs some rays and reflects others, doing so without disturbing the relative proportion of waves as they exist in the light illuminating the object.

Few objects appear as of a single pure color, however, or absolutely white or black — hence this description is far from complete. If one desires a more complete explanation of the whole matter, such books as Ralph Evans' *Introduction to Color* or the Optical Society of America's *The Science of Color,* both mentioned previously, should be consulted.

Now let us further consider our prismatic spectrum. If a prism is available, the reader should use it to project the spectral colors onto some suitable surface to see if he can gain the impression, as early investigators did, that some spectral colors are simple, whereas others are compound. (If no prism is available, the black-and-white diagram at Figure 1 will serve, to some extent, as a point of reference in the following discussion.)

Newton, over two hundred years ago, selected his famous seven steps of color (red, orange, yellow, green, blue, indigo and violet) as principal or fundamental. Later investigators thought him wrong because they found that, using only three of these

colors, they could produce all of them. Sir David Brewster concluded after long experimentation with pigments and colored glasses (which apparently contained pigments) that light waves of three primary colors — red, yellow and blue — overlapped to form the spectrum. Because of his scientific prestige, this is usually called the Brewster theory, although it is probably of much earlier origin.

For a time, apparently, this theory was unchallenged, gaining quite general acceptance both by scientists and colorists. Among its adherents was the famous Frenchman, M. E. Chevreul, whose findings, based on exhaustive experiments in color research, particularly as related to dyes (he was director of the dye department of the famous Gobelin tapestry works), still have a strong influence. Despite our improved knowledge of color in general, there is much of value to be learned about pigment application, even today, from his book, *The Laws of Harmony and Contrast of Colours,* published about a hundred years ago.

This general accord between scientists and colorists was short-lived, however. Early in the 19th century, Dr. Thomas Young conceived the theory that white light was composed of three primary bands — red, green and blue-violet (rather than red, yellow and blue) — and that these could be mixed to produce any other color. According to this theory, which was little known until more fully developed by Hermann von Helmholtz and

James Clerk Maxwell, and today is generally known as the Young-Helmholtz theory, there is present in the eye three groups of nerve fibers or photochemical substances. One group is mainly sensitive to red, one to green, one to blue-violet. Intermediate hues act upon at least two of the three groups. Yellow rays, for instance, affect the nerve fibers or photochemical substances sensitive to red and those sensitive to green at the same time, thus giving the sensation of yellow. So, according to this, yellow would not be a primary color, as in the Brewster theory, but a mixture of red and green. The sensation of white would result from equal stimulation of all three groups.

As there was no anatomical evidence of the presence in the eye of these three groups of nerve fibers as photochemical substances, the Young-Helmholtz theory, like that of Brewster, was based on the physical mixture of color. However, instead of the pigments used by Brewster, the experiments were carried on with spectral colors or with a color wheel with spinning discs, a mixing device used by Maxwell.

Even today, despite later theories concerning the perception of color, the Young-Helmholtz theory stands up well in tests of spectral color mixture. If, for instance, the spectrum is projected, by a prism or otherwise, onto an opaque screen arranged with fine slits which permit the red and green rays alone to pass through, these rays can be gathered

or made to unite or overlap on another screen, by means of additional prisms, lenses or mirrors, where they actually do appear as yellow. If to the yellow thus obtained, blue-violet rays are added, the result is white light. In other words, red, green and blue-violet rays of light actually do produce, in mixture, white light. (See Plate 1.)

This theory was disturbing to artists and colorists generally, as it did not work out with pigments as did the Brewster theory. Attempts to mix normal yellow from red and green pigments, for instance, proved failures, so speculation became common as to whether or not pigments and light followed the same laws.

Today, the physicist understands the reasons why pigments cannot give the same results in mixture as do spectral colors. It seems hardly necessary to go into them in detail here since they are extremely complicated, but we might point to the single fact that when one spectral hue is added to another, light is added to light (brilliancy to brilliancy), so that when all the spectral hues are merged, the result is bright, pure light. When a pigment of one color is added to a pigment of another color, however, each pigment having absorbed or annihilated some of the light illuminating it, dullness is, in a sense, added to dullness, the final mixture of many pigments always being neutral gray or black.

In recent years, other theories regarding the perception of color have been developed which suggest that, in addition to Brewster's pigment primaries and the Young-Helmholtz light primaries, there is a third set of fundamental colors, or, perhaps more accurately, color sensations.

Ewald Hering, a German physiologist of the late 19th century disagreed with the Young-Helmholtz theory that there were nerve fibers or photochemical substances in the eye sensitive only to red, green and blue-violet, with all other color sensations the result of simultaneous stimulation of two or more of these. Hering advanced the theory that there were three photochemical substances in the eye (he had no more proof of their exact nature, or even existence, than Brewster, Young or Helmholtz), each of which could be stimulated by a pair of opposite or complementary light sensations: red and green; yellow and blue; black and white.

These are also the paired primaries in an interesting theory put forth by Christine Ladd-Franklin, who believed the eye evolved from an elementary organ capable only of distinguishing light and dark (black and white), to an intermediate stage in which blue and yellow could also be distinguished, and finally to its present state. According to this theory, eyes with red-green color-blindness have not fully developed to what we now consider normal. Total color blindness indicates the eyes did not get beyond the light-dark stage.

Both the Hering and the Ladd-

Franklin theories are much more complicated than these brief explanations might suggest. It does not seem necessary, however, to go into them more fully here. We should mention, however, that red and green, blue and yellow, black and white have been, in recent years, accepted by psychologists as the fundamental colors in terms of vision and are now generally known as the psychological primaries. They also prove out rather consistently in medial or visual mixture, as can be shown by the Maxwell discs which make it possible to experiment with a combination of light and pigment mixture.

The Maxwell discs were first used by James Clerk Maxwell to demonstrate color mixture (see Figure 2). Colored discs, slit radially from center to circumference, can be fitted together in any combination or proportion. When two or more colors are combined and rotated at high speed on a spindle such as a spinning top or an electric fan from which the blades have been removed, they merge to appear as one, the effect of mixture being obtained through persistence of vision. (The same phenomenon can be observed by spinning almost any child's toy top and noting what happens to the colorful surface designs as the top spins.)

This method of color mixture was for many years more confusing than helpful. Although the fascinating little device blended colors to produce innumerable hues, it never quite

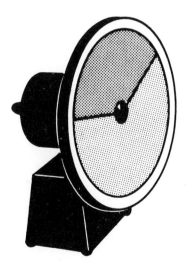

Figure 2. The device shown here is an adaptation of the Maxwell color wheel and discs. Colors are mixed visually; the primaries are red, yellow, green, and blue.

proved out with either the Brewster or Young-Helmholtz theories of color mixture. Normal blue and normal yellow do not spin out to green, as an adherent of the Brewster theory would expect, but to gray. On the other hand, normal red and normal green also produce a neutral tone rather than the yellow of the Young-Helmholtz theory.

Now that red and green, blue and yellow, black and white are generally accepted as the psychological primaries, the value of the Maxwell discs is more clearly understood. They do not obey the laws for pigment or light mixture, but rather those for visual or so called medial mixture, which seems to be a combination of both, the eye mixing the reflected light of the discs.

Although normally of little value to the painter, the Maxwell discs are quite useful in some phases of color work, particularly in conjunction with some systems of color notation.

It is interesting to note that the psychological primaries include both pigment and light primaries as well as black (which in one sense is the absence of light, but in another might be thought of as the sum total of mixing pigment primaries) and white (the sum total of light primary mixture). Another point worth thinking about in this connection is that, in mixing the light primaries to create secondaries, red and green produce yellow; green and blue-violet produce turquoise or cyan blue; red and blue-violet produce magenta red.

Plate 1. (See page 33.) These two groups of color circles demonstrate the difference between pigment color mixture (top) and light or spectral color mixture (below). Pigments reflect some light, absorb the rest. Thus some light or brilliance is subtracted by each pigment in a mixture. When the three pigment primaries — red, yellow, and blue — are mixed together, the result approximates black. Here a magenta red, a clear yellow, and a cyan blue were used; these are the three colors that in appropriate mixtures produce the most complete range of hues.

When colored light is added to colored light, brilliance is added to brilliance. A mixture of spectral colors is brighter than any individual color. A mixture of the three light primaries — red, green, and blue-violet — produces white light.

These light secondaries are almost identical with the pigment colors usually accepted as primary. When we mix our pigment primaries to create secondaries, however, the results are orange, purple and green, green being the only light primary of the three. There would seem to be a correlation of some kind between the light and pigment primaries, but, if there is, its exact nature seems, so far, to have eluded the most determined investigators.

Of course, the physicists, physiologists, psychologists and chemists — as well as colorists in many phases of industry and art — are constantly exploring all the aspects of the behaviour of color and may one day solve its mysteries. In the meantine, the puzzle often seems to become more puzzling. For instance, Dr. Edwin Land, inventor of the Polaroid Land Camera, while carrying out a series of experiments relating to color photography, discovered he could project a full-color image on a screen through black-and-white transparencies, using only two colored lights. His experiments, reported in the May 1959 issue of *Scientific American,* raise many new questions on the nature of color vision. They may eventually lead Dr. Land or others to the key.

Meanwhile, what does all this mean to the student painter? Once he is aware of the fact that color is a complex subject that often baffles the most scientific minds, how can he best begin his own studies?

First, he can turn his back on all the puzzling things the scientists are discussing, at least for the time being. Accepting a few facts of proven worth such as outlined here, he can employ them as a basis for pigment experimentation, gradually learning to know color through using pigments in attempts to represent such effects of color as he sees about him. He will try to analyze color appearances, in other words, and endeavor to express them with his pigments by painting.

Since he is working with pigments rather than light, let him hold to Brewster's red, yellow and blue as his primaries, adding to them such other hues as seem to him most essential, according to his individual requirements.

Then let him experiment with these pigments, following such progressive exercises as we offer in this volume, secure in the knowledge that whatever he learns of color from such experimentation can be utilized later in all his color problems.

The student who thus elects largely to ignore the findings of the scientists, turning immediately to practical experimentation with brush and paint, can do so with the assurance that he is following in the footsteps of a vast host of artists who have successfully pursued a similar course before him. For even of the acknowledged experts in the field of color — experts who attribute no small part of their success in such professions as painting, architecture,

interior decoration and industrial design to their ability to use color well — many a man has acquired his grasp in what might seem an extremely haphazard manner, picking up an idea here and another there, experimenting, comparing and analyzing over a long period of time (perhaps with pigments, though possibly with building materials, fabrics, etc.) until he has accumulated a fund of color facts and developed an indefinable feeling for color — increased sensitiveness to and appreciation of it — which grows and changes with the years.

The second course open to the student is more difcult than the first, particularly if he is young or impatient. Certainly it is far less commonly followed. Before starting with pigments at all, he would make an effort to ground himself thoroughly in the fundamentals of science as they relate to light and color. He would investigate such theories and opinions and laws as we have touched upon, which would involve reading many books (and doing some acute thinking as well), for we have introduced our reader to only a few of the intricacies and complexities of the subject.

It is evident that the student who conscientiously follows this latter course will have quite a delay before he gets to his consideration of pigments. Even then he will have acquired little knowledge directly applicable to his daily problems; he must still experiment and experiment, as every artist does. His scientific knowledge may even deter him from painting in the bold, free manner which is generally productive of the finest results.

Perhaps the best move of all is to compromise by combining these two courses, with emphasis mainly on pigment practice. It seems hardly wise to risk, just at first, the mental indigestion which would be almost sure to follow any attempt to straighten out at once all the tangle of seemingly irreconcilable theoretical and practical matters. Possibly the beginner would do well to go ahead with his exercises with pigments for some time, undisturbed by anything else. Pictorial representation, being mainly imitative and taking its color schemes largely from nature, can be done successfully with little or no knowledge of the laws of light and spectral color. Later, he could investigate such of these laws as his pigment practice brings to his attention or his individual requirements seem to demand. He will need increased scientific knowledge if he turns to forms of creative art which involve the direct use of light itself — leaded glass, for instance. Theatrical design and window display work are even more complex, as lights and pigments are employed in combination. This volume, in guiding him through his practical work with pigments, directs attention now and then to some of the contacts which he can advantageously make between the two fields of art and science.

Whatever course the student adopts at first, it is quite likely that he will eventually find himself anxious to explore some of the theories and laws of the scientist. Even those which prove impractical to him will at least enrich his general knowledge and appreciation of color. If one fails to investigate this scientific material, he is almost certain to deprive himself of a wealth of adaptable suggestions which have been developed during centuries of intelligent and conscientious research on the part of many earnest workers approaching the subject of color from every possible point of view. The longer one studies, the more he comes to realize that some theories or laws, which on first comparison seem poles apart, actually are, at least when it comes to their practical application, parallel rather than divergent. The student who studies them thoroughly will find that they lead in the same direction — forward.

The Qualities of Color and Their Measurement

Having introduced the reader, however slightly, to the fascinating, but often puzzling, theoretical aspects of color, we turn now to color as an artist sees and uses it. It is our aim to keep this volume as free as possible from technical terms. Some are bound to creep in, however, and, as we approach exercises in which "hue," "value," "intensity" and related terms must be employed, it becomes imperative to offer a few definitions and explanations. We shall confine ourselves, however, to the vocabulary of the artist, ignoring, for the most part, that of the scientist.

Qualities of Color

If we look at any given color analytically — the red of an apple, for instance — we discover that it possesses three outstanding characteristics or qualities. First, there is that quality by which we recognize one color from another, and which we suggest by its name. This we call "hue." The apple is red; red is the hue (name) of the color. Remember the equation: "Hue equals Name."

We can alter the hue of a color by mixing another color with it. If we mix red pigment with yellow pigment, we produce orange pigment; this is a change of hue.

Next comes the quality by which we discern lightness or darkness in a color. This we call "value." It is by value that we are able to discriminate between light red and dark red.

By mixing a color with something lighter or darker than itself, we change its value. If we mix black or white (or water, in the case of water-color pigments) with a color, we change its value but not its hue.

A color in its full, natural strength may be called a "normal" color or a color of "normal" value. If lighter, we call it a "tint"; if darker, a "shade." These latter terms are so often abused that some authorities prefer the substitution of the word "value," as a "light *value* of blue" rather than a "*tint* of blue," or a "dark *value* of green" rather than a "*shade* of green." "Tone" is a word of

ambiguous meaning which is often employed in a general way to include all normal colors, tints and shades. Some authorities, however, use it to refer specifically to grayed values of any hue. Thus, color mixed with white would be described as a tint; color mixed with black, a shade; and color mixed with both black and white, a tone. If these words were always used in just this way, it would doubtless be easier to communicate color distinctions more accurately than we now do, but in common usage all three words are used almost interchangeably.

Some colors are strong and some weak. The quality by which we distinguish strength or weakness in a color is called "intensity." If we remark that an object is colorful or strong in color, we refer to its intensity.

We can change the intensity of a normal color by mixing it with other hues; this tends to dull or gray it. We can change intensity without changing value or hue by the addition of neutral gray of equal value.

This quality which we call "intensity" is also called "chroma" or "saturation" and the value of a color is sometimes termed "brightness" or "lightness." Though these particular differences in terminology are of slight consequence to the average artist, they emphasize the unfortunate confusion of terms which exists in the entire field of color.

Take, for instance, the matter of color names. There are literally thousands with new ones invented every day by imaginative copywriters. Few are truly descriptive. There are colors named for flowers or plants, such as rose, violet, indigo; for fruits — orange, plum, peach, lemon; for places — Antwerp blue, Nile green; for persons — Hooker's green, Payne's gray, Rembrandt's madder. The inadequacy of such terms is evident. As A. H. Munsell asks in his book, *A Color Notation:* "Can we imagine musical tones called lark, canary, cockatoo, crow, cat, dog or mouse, because they bear some distant resemblance to the cries of those animals?"

Aside from color names, there are many other color terms equally ambiguous or unstandardized, such as those just presented in our description of color qualities. The scientiste wrangle over one lot of words, ths colorists over another, and neither group has developed a universally accepted terminology, comparable to that of music. So, despite the wealth of color terms, it is extremely difficult for one to put in words a description of a color scheme, or even an individual hue, with any likelihood of being exactly understood.

This does not mean that no attempts have been made to bring order out of this chaos. The problem has long been evident and steps toward its solution have often been undertaken.

First, it has been demonstrated that the color qualities which we have described as hue, value and intensity

are measurable, each of them being really a dimension. Color, in other words, is three-dimensional.

Secondly, though no one color yardstick or system of measurement has met with anything approaching universal acceptance or application, several ingenious systems have been devised and are in actual use, particularly in industries where the precise specification of color is of great commercial importance (printing inks, textile dyes and wall paints, for example).

Since the main purpose of most of these systems is to provide an accurate means of identifying, specifying or matching colors, each has developed a set of physical standards and notations which, when properly understood, can describe the three dimensions of any color. Although extremely helpful to the color specialist who can interpret them, they are meaningless to the average artist who has little use for them in his own painting.

For those readers who may wish to investigate these systems, we strongly recommend several books which explain more clearly and effectively than we could possibly attempt here the theories behind the organization and use of the Munsell, Ostwald and Birren color systems, these three being perhaps the best known and most widely used at the present time. All three systems are covered rather well in Frederick M. Crewdson's *Color in Decoration and Design* (Frederick J. Drake and Co., Wilmette, Ill.) and in Faber Birren's *New Horizons in Color* (Reinhold). For those who wish a more detailed analysis of the Munsell System, there is Munsell's own book *A Color Notation*. Egbert Jacobson's *Basic Color* (Paul Theobald), a very lucid, detailed interpretation of the Ostwald System, is well illustrated with many helpful color plates and includes a section analyzing the color schemes of several old and modern masters in terms of the Ostwald theories of color harmony.

As we have stated, however, the average artist finds little use for such systems. We have seen that the artist's concern is less with color theory than with pigments, which are used, for the most part, for picturing objects of all sorts as they appear to the eye. And these objects, as well as the pigments themselves, convey color impressions modified by what, for want of a better term, we call texture.

Texture, therefore, though not truly a quality of color, as are hue, value and intensity, is so closely related to these qualities that it must be considered along with them. If one paints an object, he must keep in mind its shape and character as revealed by its color (hue, value and intensity) and texture. The light and shade on objects can be thought of as agents for the expression of shape and texture, as modifiers of color. Even in non-objective paintings, for that matter, texture is a very important factor; since there is no subject in-

terest, texture is often one of the painting's chief attributes. In fact, some non-objective painters are noted primarily for the textures they achieve with unusual materials such as sand or mud, or the fact that they apply their pigments in some unorthodox way, such as dribbling, which creates a particular textural effect.

But, to return to the representational painter — or the world as he sees it — it is largely by texture (whether a mere surface texture or a surface revelation of deeper seated physical characteristics) that we know whether a thing is of metal or cloth, wood or plaster. If fabrics of silk, cotton and wool, originally white, are all dyed with the same dye, each can still be identified by its individual textural characteristics. Architects, decorators and designers of all kinds must know the importance of textures and choose such things as building materials, fabrics and finishes according to texture, as well as other characteristics. And the artist, to portray his subjects properly, must express texture together with color, choosing his materials — canvas, paper, pigments, etc. — accordingly.

In the final analysis, it is always the artist's eye, and his eye alone, which will be his instrument of color judgment. No systems or theories can ever be of more than limited value. He must learn color mainly through observation of natural colors and through his use of color in pigment form. For this reason, we shall place great emphasis, as we go along, on experiments with pigments, organized for the student's own performance.

Color as Pigment

In the language of the scientist, pigments — whether those used by the artist, the dyer or other colorists — are called "colorants" (substances that produce color) to distinguish them from colored light. This distinction helps to clarify the thinking of the physicist and chemist on the many aspects of color and, for the artist with a scientific bent, it may give some clue to a very confusing subject. As a rule, however, artists are not concerned with scientific accuracy in the use of such terms. To painters everywhere, color is color, whether light, pigment or the reflected light of a pigmented surface. We shall, therefore, discuss color henceforth from the artist's viewpoint, primarily in terms of pigments and the way be uses them.

Pigments

The use of pigments for painting would seem to be as old as man. No one really knows when man first discovered that by mixing together certain materials he could create a substance with which to ornament himself, his clothing and his surroundings, but the comparatively recent discovery of the cave paintings in southern France, in Spain, and in Africa has revealed that 20,000 years ago, at least, men had learned to paint with reds, yellows, browns and blacks made from iron oxides and manganese.

If we skip from the mysterious artists of pre-historic times to the more familiar ancient civilization of Egypt, we find that there are still in existence wall paintings two to five thousand years old, many remarkably well preserved, showing that Egyptian artists made excellent use of copper-based blue and green pigments as well as whitewash, soot black, and red, yellow and brown ochres.

Through the centuries, other pigments have from time to time been added to the colors available to the artist. Some of them — genuine ul-

tramarine made from lapis lazuli, for instance — are very beautiful but extremely expensive. Others, like emerald (Paris green), are poisonous if swallowed (and more than one artist has been known to touch the tip of his brush to the tip of his tongue). Worst of all, however, are those which appear beautiful when the painting is first finished, but quickly fade or change color on exposure to light. (Many paintings of the past have been ruined by the lack of permanence of the colors used or by the painter's lack of knowledge of the chemical interaction of his pigments). During the past century, and particularly in the last few decades, modern chemistry has added a surprising number of new pigments to the artist's palette. Some are exceedingly beautiful, many of them appear to be absolutely permanent, and several are excellent replacements for less reliable colors.

To make paint, pigment is ground up into a powdered substance and mixed with liquid. In oil paint, the powdered pigment is mixed to a thick consistency with oil, usually linseed. In watercolor paint, the pigment is ground up with water-soluble gums, usually gum arabic. Other mediums are egg albumen for tempera, and size for distemper. In the past, artists usually served an apprenticeship of several years during which they learned to grind and mix colors for the master. Today, some painters still prefer to prepare their own colors, but the majority of artists today — professionals as well as students and amateurs — usually buy the colors, already prepared, of one of the reputable manufacturers.

For anyone interested in a detailed discussion of how raw materials are turned into artists' colors, we recommend one of the excellent books devoted to the craftsmanship of the painter. Max Doerner's *The Materials of the Artist and Their Use in Painting*, Ralph Mayer's *The Artist's Handbook of Materials and Techniques*, and *Painting Materials* by Gettens and Stout, are standard reference works.

In these volumes you can find detailed analyses of hundreds of colors. Many of those listed are simply synonyms — names used in different countries or at different periods or by various manufacturers — for the same pigment. (One book gives 11 names for White Lead alone!) With such an array of colors and color names, it is no wonder if the student painter is confused and uncertain about which to choose for his own palette.

Selecting a Palette

The word "palette," like other words we have been discussing, has more than one meaning. It refers, of course, to the object on which an artist squeezes out and mixes his colors (which may be an ordinary white dinner plate for the watercolorist, a traditionally shaped board with thumbhole for the oil painter, or any other convenient surface that

suits the painter). But " palette " also refers to the assortment of colors an artist uses. It is in this latter sense that we will be using the word for the most part now.

Strange as it sometimes seems to the beginner, who wants to be told precisely what to do and what not to do, the selection of colors for an artist's palette is largely a matter of personal preference. If you ask a dozen experienced painters for suggestions, you will receive a dozen different lists. To be sure, certain colors will turn up on all, or almost all, of the lists; but each painter will have certain preferences and prejudices based on his own experiences, his own methods of working, and, inevitably, that indefinable and unpredictable thing, his own taste.

Furthermore, he will often differentiate between the list of colors he likes to have on hand and the ones he feels he couldn't get along without. For some subjects, a painter may use only a few colors; this is usually referred to as a " limited palette. " For other subjects, the same painter may feel he needs a wide range of hues. Perhaps the best course for the beginner is to choose a reasonably wide assortment of pigments based on the suggestions in this chapter. Then, after he has become thoroughly familiar with the effects he can achieve with these pigments (the exercises in later chapters can be particularly helpful in this respect), he will be able to make future selections based on his own experience.

The following lists, selected from various books on painting techniques (which the student painter might very well read with considerable profit), reveal both the similarities and differences of opinion that exist among various well-known artists and artist-teachers. The reader will also note several important differences between the lists offered by those whose work is primarily in oil and those who prefer to work in watercolor.

Palette Suggestions for the Oil Painter

In *Oil Painting for the Beginner* (Watson-Guptill), Frederic Taubes suggests the following basic list of colors as a starter: White Lead (Flake White), Prussian Blue, Ultramarine Blue, Viridian Green (Chromoxide Green Transparent), Yellow Ochre, Cadmium Yellow, Venetian Red, Cadmium Red, Alizarin Crimson, Burnt Sienna, Burnt Umber and Ivory Black. As additional colors, he recommends Naples Yellow, Cadmium Orange, Indian Red and Cerulean Blue.

Jerry Farnsworth's *Learning to Paint in Oil* (Watson-Guptill) contains the following list of essential colors for the oil painter: Zinc White, Cadmium Yellow Pale, Cadmium Yellow Medium, Cadmium Orange, Cadmium Red Light, Cadmium Red Deep, Yellow Ochre, Raw Sienna, Venetian Red, Burnt Sienna, Raw Umber, Alizarin Crimson, Viridian, Ultramarine Blue, Cobalt Blue, Cerulean

Blue, Ivory Black. Other colors which he likes to use at times are Oxide of Chromium, Mars Violet, Payne's Gray, and the Manganese Blues and Greens.

Palette Suggestions for the Watercolor Painter

In his book, *Watercolor for the Beginner* (Watson-Guptill), Jacob Getlar Smith lists 29 colors which he has placed in eight separate groups. Of these, he states: "If you choose at least one from each group, there will be at your command a range of colors flexible enough for any desired result. Their permanence has been guaranteed by use over many years."

The colors are grouped as follows, asterisks indicating the suggested palette: *Group I* - *Cadmium Yellow Pale or Lightest, *Cadmium Yellow Deep, *Cadmium Orange, Aureolin; *Group II* - *Cadmium Red Light or Lightest, *Cadmium Red Deep, Scarlet Vermilion, Rose Madder (permanent only when not mixed with earth colors); *Group III* - Yellow Ochre, *Raw Sienna, Mars Yellow; *Group IV* - *Raw Umber, Burnt Umber, *Burnt Sienna; *Group V* - Venetian Red, *Indian Red, Light Red; *Group VI* - *Viridian, Oxide of Chromium, Monastral Green; *Group VII* - Monastral Blue, Lamp Black, *Ivory Black, Mars Black.

Another well-known watercolor painter, Ted Kautzky, in his book, *Ways with Watercolor* (Reinhold), lists the following colors which make up his regular palette: Alizarin Crimson, Burnt Sienna, Burnt Umber, Raw Sienna, Raw Umber, Hooker's Green No. 2, Davy's Gray and Payne's Gray, Orange Vermilion, Cadmium Orange, Cadmium Yellow, Aureolin, Lemon Yellow, Cobalt Blue, French Ultramarine Blue and Winsor Blue. Kautzky points out that in any single painting he usually confines himself to ten colors or less, sometimes working with only three or four.

Brands of Colors

As to brands of colors, again practically every painter has his personal preference. In today's stiff competition it is apparently safe to assume that any of the well-known brands will give satisfaction. Those mentioned most frequently by the painters whose palette suggestions we have listed are Winsor & Newton, Rembrandt, Weber, Permanent Pigments, Grumbacher, and Shiva. The main thing is to realize that you get just about what you pay for. The cheaper lines of colors — sometimes known as "students' colors" — cannot be expected to be as satisfactory in the long run as those made for professional use.

You may want to experiment until you determine the make best suited to you. On the whole, though, you will find it is safer to stick to one brand, once you are familiar with it, for you will gradually learn exactly what to expect from every color in that particular line. Artists often learn with surprise and regret that

a given color of one make may be quite different in hue or consistency from some other manufarctuer's product bearing the same or a similar name.

Permanence

Regardless of make, some pigments are less durable than others, causing paintings to darken, fade or discolor with age. They should, therefore, be avoided altogether or used sparingly, or only in minor works. This does not mean that the artist must know color chemistry, for many manufacturers make available, on request, full descriptions of their products. Winsor & Newton, for example, lists three groups of colors: one absolutely permanent, one moderately durable, one fugitive. From these they recommend a " Selected List " of colors which are both non-fading and mutually inactive chemically — in other words, foolproof. The tube of each color on this list is stamped " S. L. " (in red) for instant identification. Other manufacturers indicate the relative permanence of each of their colors on charts that can be consulted at your dealers. Permanent Pigments has a small brochure called " Enduring Colors for the Artist " which is a simplified treatise on artists' colors, how they are made, and how they may be expected to behave in oil, watercolor, casein and other special mediums. It will be worth your while to learn all you can about the pigments you

buy. If in doubt, don't hesitate to ask your dealer for advice. Often he can be most helpful.

One important point to keep in mind as you hear or read conflicting opinions on the permanence or behaviour of particular colors is that some colors which have a poor reputation in one medium are most dependable in another. Another reason for disagreement on this matter is that some artists are aware of the limitations of certain pigments and have learned how to make use of them, whereas other painters either haven't learned or perhaps don't wish to be bothered. A third source of confusion is the fact that recent advances in the development of paint chemistry have given us new substitutes, seemingly permanent (though in some cases not yet subjected to the test of time) for older, less dependable colors. In many cases the new color is called by the same name as the old one which it resembles in appearance but not in chemical composition.

Setting the Palette

Whatever the colors finally selected for your palette, they should be systematically arranged in some particular order so that you will be able to reach for the right pigment and find it whenever you want it without fumbling. Many artists speak of their palette arrangement as being like the keyboard of a piano — each note or tone in a particular spot in

relation to all the other tones. However, artists' palettes are very different from keyboards in that each artist makes his own selection and arrangement of colors (or tones) and establishes relationships that may seem very strange to other artists but which happen to suit his own working habits.

There are really no rules — aside from convenience — but many artists find it most helpful to base their arrangement on the spectrum. (See Figure 3.) In such an arrangement, the reds come first, then the oranges and yellows, next the greens, blues and violets, and finally the browns, blacks and whites. In another common arrangement the warm colors and the cool colors are placed in separate groups. This type of grouping is used in the two palettes shown in Figure 4 — one a basic palette and the other, a more advanced palette. Another scheme is the grouping of colors which are frequently used in combination. Sometimes watercolor painters arrange their colors in two major groups: the first consisting of colors which insure smooth, clear washes; the other, those that produce sediment washes.

Jerry Farnsworth, whose list of suggested colors was given previously, arranges his oil paints on a rectangular thumbhole palette with Zinc White in the upper left-hand corner. Across the top from left to right are the cadmiums from pale yellow to deep red, then the earth colors. Down the left side of the palette are Alizarin Crimson, the blues, Viridian and black. The center is left free for mixing.

A useful trick used by some painters is to make several dabs of each color on the palette rather than one large one. This makes it much easier to keep each color — particularly white and light yellows — clean and clear.

A Selected List of Pigments

Following is a list of commonly used pigments with brief descriptions of their qualities:

White

White Lead, Flake White, Cremnitz White — three names for the most popular white used in oil painting. Although it is poisonous (and for this reason is never used in watercolors or in children's paints) and tends to yellow in impure air, many artists prefer it to other white paints because it brushes on easily, covers well, dries rather quickly and has a pleasing appearance, both by itself and in mixture with other pigments.

Zinc White, Chinese White — a purer, colder white than White Lead, Zinc White is not poisonous and does not darken. However, it is less opaque, dries more slowly and doesn't brush out as well. As Chinese White, it is used chiefly in watercolor and gouache.

Titanium-Zinc White — mixtures of Titanium Oxide and Zinc White —

Figure 3. A typical dinner plate palette, preferred by many watercolor painters, with pigments arranged according to the spectrum. The center of the plate is free for mixing.

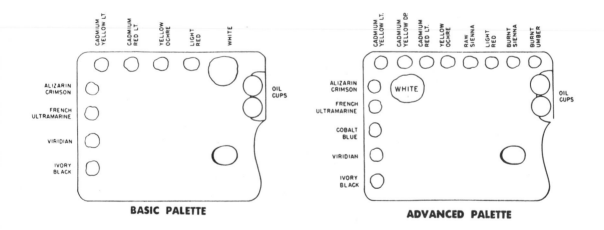

BASIC PALETTE

ADVANCED PALETTE

Figure 4. Warm colors are placed along the top of the palette, and cool colors along the side in the palette arrangements of oil paints shown here.

are sold under various brand names and are preferred by many artists to Zinc White itself.

Yellows

Aureolin (Cobalt Yellow) — rather muddy as it comes from the tube but, when lightened with white or thinned with medium, becomes a bright transparent color. Sometimes used as a primary yellow in color charts and color mixing.

Cadmium Yellows — a series of bright, slightly opaque yellows, ranging from very pale lemon to orange. Permanent but do not mix well with Emerald Green, Naples Yellow and some other colors.

Strontium or Lemon Yellow — a clear, pale, slightly opaque, greenish yellow.

Naples Yellow — somewhat opaque, medium yellow. True Naples Yellow is similar in composition to White Lead and has the same qualities, both good and bad. However, tints of other yellows mixed with white are sometimes sold under this name, so be sure of what you are getting.

Yellow Ochre — an earth color, one of the oldest in use as an artist's pigment; semi-opaque, dries fairly well. Its dull yellow tone is a great favorite with painters.

Raw Sienna — an earth color, similar to Ochre, but deeper, more brownish in tone; produces interesting sediment washes when used in watercolor.

Mars Yellow — an artificial iron hydroxide pigment, similar to Ochre and Raw Sienna.

Reds

Alizarin Crimson — a good bright red, pure, clear, transparent; very useful for producing rose tints and (in mixture with Ultramarine or Cerulean Blues) purples and violets. Dries slowly. Reasonably permanent under normal conditions.

Rose Madder — a transparent color, somewhat more delicate than Alizarin Crimson; also mixes well with blues.

Cadmium Reds — a series of brilliant, opaque reds, ranging from light scarlet to deep maroon. Cadmium Scarlet and Cadmium Vermilion are often used today in place of true Vermilion which has a tendency to blacken.

Light Red, English Red, Indian Red, Venetian Red, Mars Red — although somewhat similar in hue as they come from the tube (all are rather neutral brownish reds made from iron oxides), each of these colors produces a slightly different tint when mixed with white. All are opaque, have good tinting strength and are moderately good driers.

Blues

Ultramarine and French Ultramarine — a deep blue with a slight reddish cast, transparent, dries moderately well. Sometimes called Permanent Blue or New Blue.

Cobalt Blue — similar to Ultramarine at full intensity, but with a slightly greenish tone.

Cerulean Blue — a deep azure blue, opaque, dries very well, has good tinting strength and hiding power. An expensive color, so beware of cheap substitutes masquerading under this name.

Prussian Blue — a deep blue with a slightly greenish tone in glazes and tints; tremendous tinting strength (it must be used with care); rather transparent; dries well.

Manganese Blue — a bright greenish blue, similar to Cerulean but lighter and with less tinting strength.

Phthalocyanine Blue — a modern synthetic pigment (often sold under special brand names), an intense, powerful color similar to Prussian Blue and Antwerp Blue, which it is gradually superseding. Very useful for mixing greens.

Greens

Although greens can be mixed very easily from blues and yellows, many artists prefer to have at least one or two of the following greens on their palette.

Viridian — a clear, transparent green of emerald hue; best used as a glazing color in oil or for transparent watercolor washes; mixes well with other pigments to produce a variety of blues and greens, but tends to become dull and blackish when put on in heavy layers.

Phthalocyanine Green — a variant of Phthalocyanine Blue; more intense than Viridian which it resembles.

Chromium Oxide Green — a somewhat dull willow green, rather opaque, low tinting strength.

Green Earth (Terre Verte) — a transparent, pale green, slightly olive in tone; most useful in glazing and for watercolor washes.

Hooker's Green — an intense, transparent, mixed green, popular with watercolorists. Although the traditional mixture of Gamboge and Prussian Blue was of doubtful durability, the mixtures now sold under this name are said to be permanent.

Violets

Violets and purples are usually mixed from blues and reds, but the following pigments are sometimes useful additions to a palette.

Cobalt Violet — a bright, transparent reddish violet; poisonous (therefore used only in oils and adults' watercolors).

Manganese Violet — a cool, opaque color; strong but not brilliant.

Mars Violet — an iron oxide pigment, similar to Indian Red but more bluish.

Browns

Burnt Sienna — an extremely versatile and dependable color on the border line between red and brown. Equally useful as an opaque color or as a transparent glazing color; produces interesting sediment washes

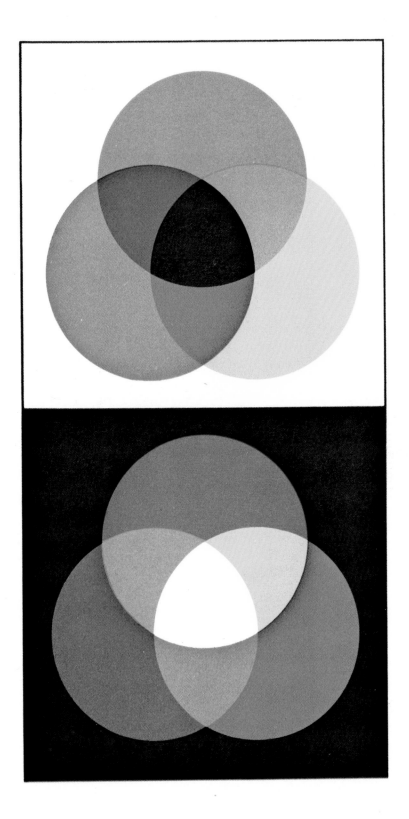

PLATE 1

See page 16.

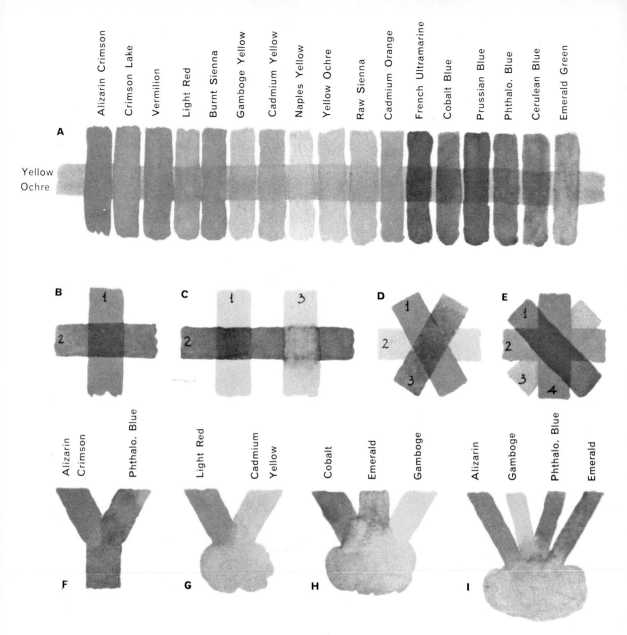

Experiments in overlaid washes are shown at top and center; examples of mixed washes are shown below. In A, a narrow band of yellow ochre was overlaid by short washes of other colors. In B and C, only two hues were crossed. In C, French Ultramarine was washed over Gamboge Yellow with little damage, but the yellow over the blue is streaked. Combinations of three and four hues gave the neutral, muddy results in D and E.

In F two washes were run together on the paper while wet to form a mixed wash. G, H, and I show mixed washes of two, three, and four colors, blended with a rotated brush.

PLATE 2

PLATE 3

See page 83.

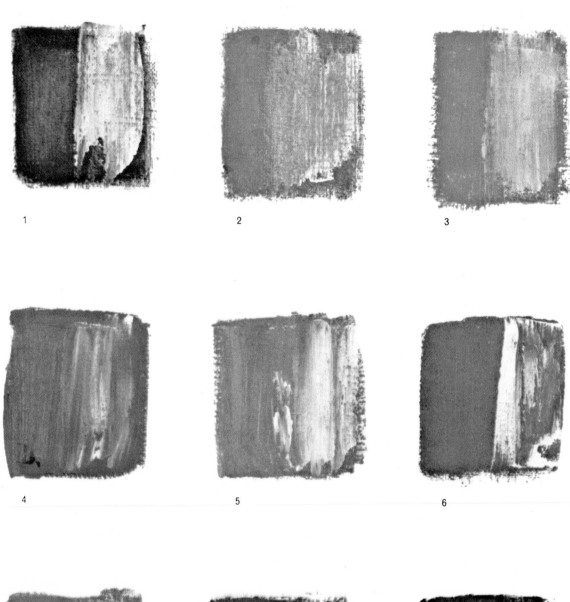

1 2 3

4 5 6

7 8 9

PLATE 4

 See page 83.

1

2

3

4

5

6

7

8

9

PLATE 5

See Page 86.

PLATE 6

See Page 86.

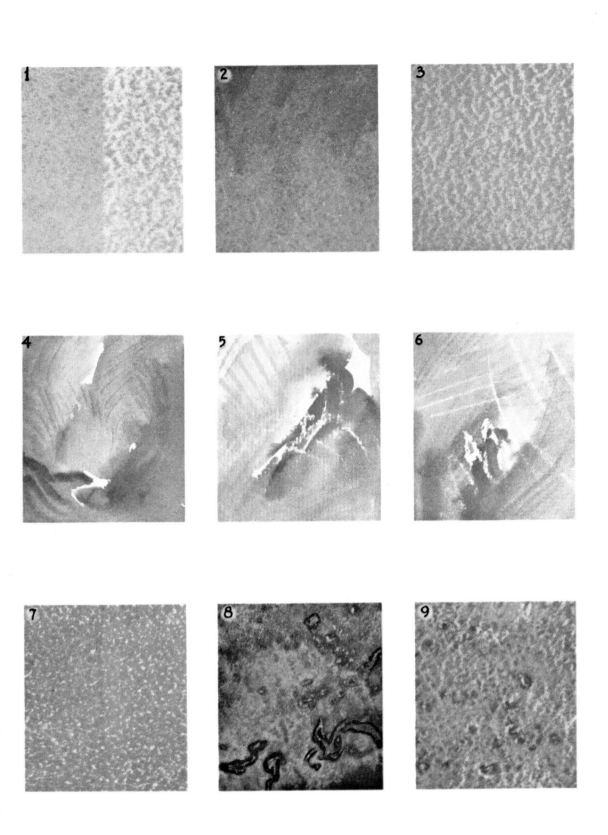

PLATE 7

See Page 86.

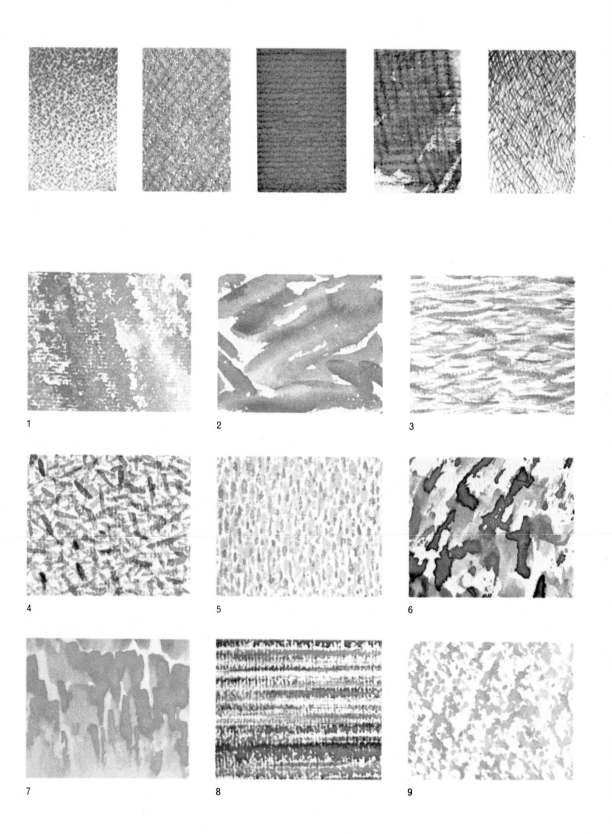

1

2

3

4

5

6

7

8

9

PLATE 8

See Page 87.

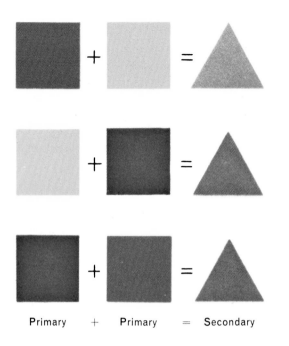

Primary + Primary = Secondary

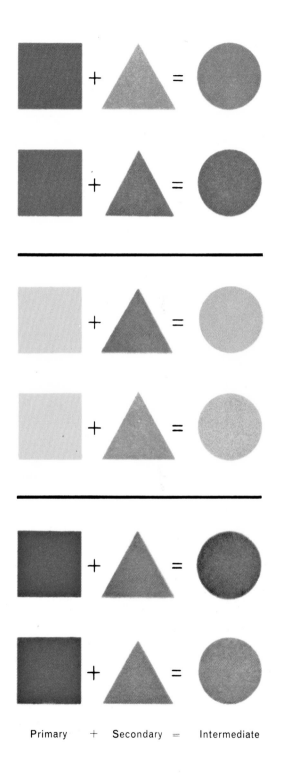

Primary + Secondary = Intermediate

This chart demonstrates the principles of pigment mixture. Red, yellow, and blue are the pigment primaries: mixed together in pairs, they form the secondaries — orange, green, and violet. Certain pairs of primaries and secondaries mixed together form the six intermediate colors — red-orange, red-violet, yellow-green, yellow-orange, blue-green, and blue-violet. Other pairs of primaries and intermediates — red and green, orange and blue, yellow and violet — are complementary and neutralize each other when mixed together.

PLATE 9

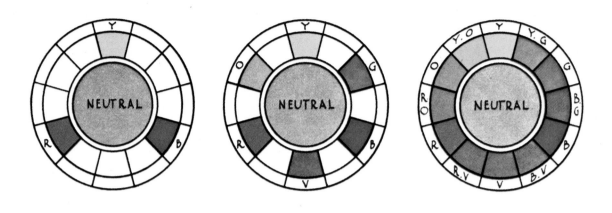

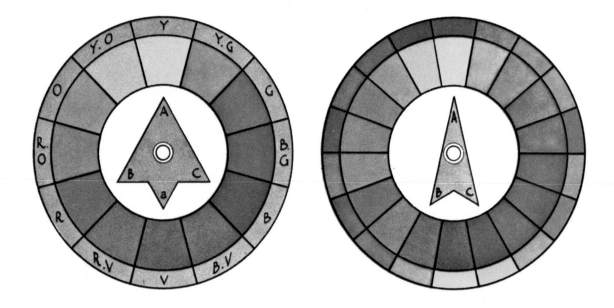

Here is a method of preparing a color wheel as a scale of hues. Draw the wheel and place your three pigment primaries (top left). Then add the three secondaries in between the primaries (top center). Complete the wheel by adding the six intermediate hues (top right). Fill in the centers with neutral gray. A 12-hue wheel with a movable device for locating complements and triads is shown at bottom left; an 18-hue wheel with a movable device for determining split complements is shown at bottom right. On the 18-hue wheel, the complement of each color in the inner circle appears on the outer rim.

PLATE 10

Within the chart, the labeled swatches read:

TINT

TINT

NORMAL

SHADE

SHADE

PLATE 11

See Page 92.

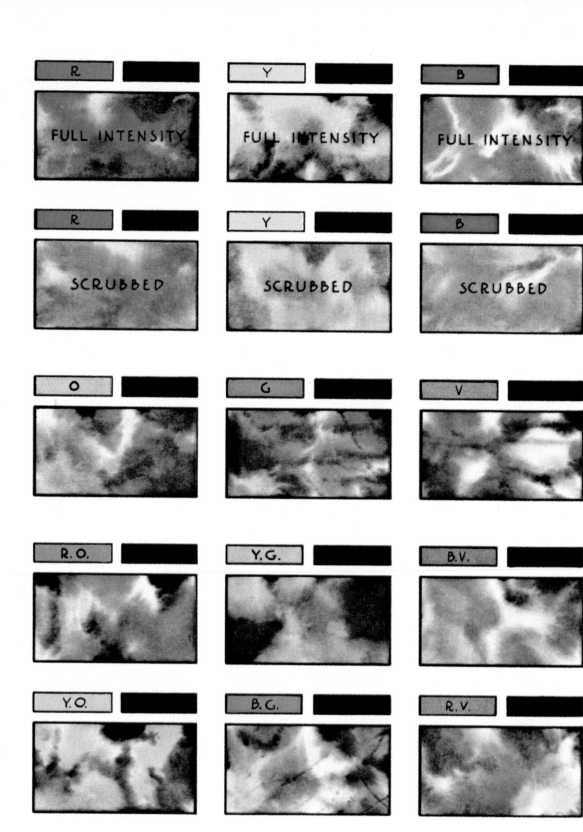

PLATE 12

See Page 118.

44

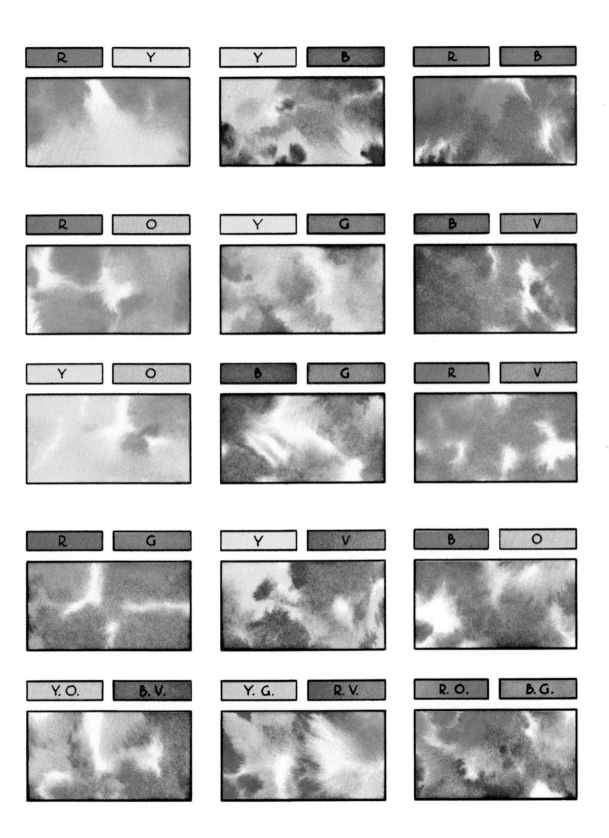

PLATE 13

See Page 118.

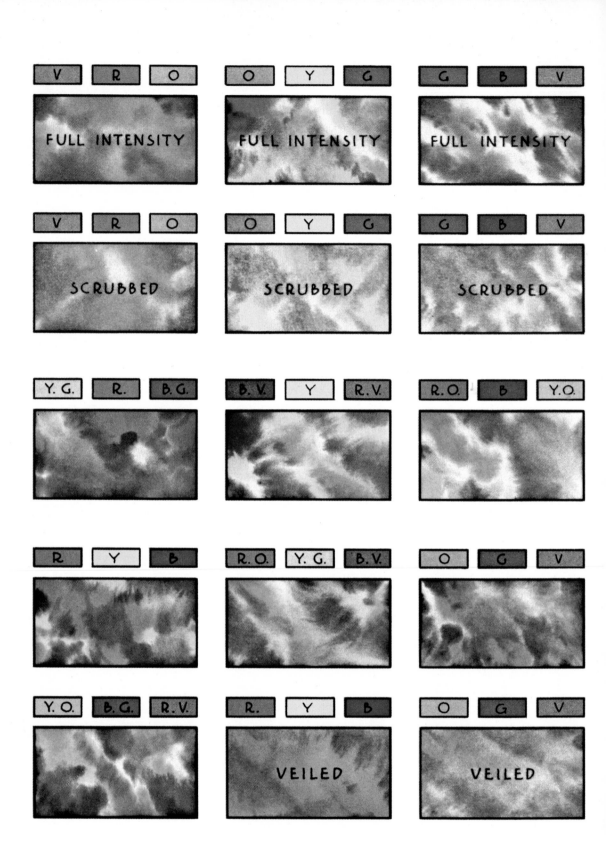

PLATE 14

See Page 121.

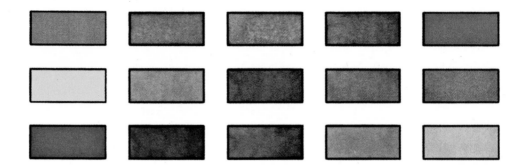

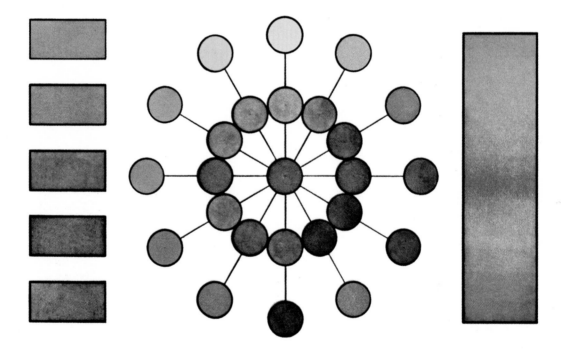

The neutralizing effect of mixing complements is shown at top in three intermediate steps between the primary colors and their complementary secondaries. Between each primary and its complementary lies a neutral gray. At center left is a stepped scale showing intensity. At center is a color wheel as a scale of intensity. The panel at center right shows green shaded to its complement, red. The five rectangles at the bottom demonstrate the power of complements to neutralize or intensify each other, depending on how they are used and their relative areas. Two complements may be neutralized by mixing, by dotting, and by lining; they may be intensified by striping and by contrast. (See Chapter 7.)

PLATE 15

47

when mixed with Ultramarine; dries moderately well.

Umber — another versatile earth color, useful in both opaque and transparent techniques. Raw Umber has a slightly greenish tone; Burnt Umber tends toward red. Both have tremendous drying power, which can be very useful (but take care not to use them at full strength for underpainting; slower drying pigments painted over them may well crack).

Blacks

Ivory Black — originally made by burning scraps of ivory, now made from charred bones, this is the principal black used by artists. It has good tinting power but is a poor drier.

Mars Black — a dense, warm black made from iron oxide.

Watercolor — Equipment and Basic Techniques

One of the advantages of watercolor painting is that it calls for but little in the way of equipment. In the previous chapter we have already discussed the matter of choosing one's pigments — whether for oil or watercolor work — and arranging them on a palette. Now, before we begin the first exercises in watercolor technique, we shall consider briefly the other materials needed before you can start to work.

Brushes

Brushes are of great importance. Cheap ones on the whole are of doubtful value. As one needs but few brushes, he should buy the best. Those of red sable hair are generally so considered. The round, sharply pointed type is probably the most popular, but flat square ones can also be useful at times. A rectangular space such as a door or window shutter, for instance, can often be painted with lesing a stroke of a flat, sable brush about three-fourths of an inch wide.

One generally needs about three round red sable brushes — small, medium and large. For any given piece of work, it is best to use the largest size brush practical. Small brushes require too frequent dipping and can lead one into finicky ways. For bold sketching (such as outdoor work) and for laying large washes (as on skies and backgrounds), so big a brush is needed that one sometimes feels forced to use a cheaper substitute for sable, such as imitation sable, camel hair or squirrel. The Number 17 camel hair "dabber," for instance, costs a fraction of the price of a red sable brush the same size. However, since camel hair brushes lack spring and seldom hold their points well, they are not recommended except in the large sizes for bold work.

For certain types of work, particu-

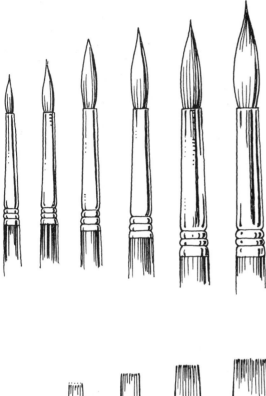

Figure 5. Round red sable brushes in several sizes are preferred for most watercolor work (top left). Flat red sables are useful for single strokes (center left). Bristle brushes are used for scrubbing out highlights (bottom left). In the larger sizes camel hair brushes are an inexpensive substitute for sable (bottom right).

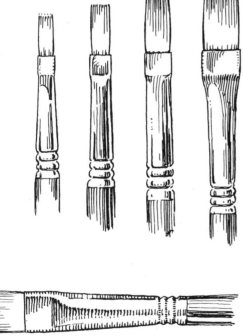

larly for scrubbing out high lights, stiff bristle brushes are sometimes used.

Care of Brushes

With proper care, good brushes will give years of service. Rinse them frequently, as you use them, and wash them thoroughly when you put them away. Don't leave them standing for long periods in paint or water — and don't allow them to dry in cramped positions.

Paper

The most desirable papers for watercolor painting are usually handmade and imported, the best known perhaps being Whatman from England, Arches from France, and Fabriano from Italy. These papers are handmade of the very best rag stock, following traditional methods handed down through the years from father to son (not at all practical here in the United States); their properties are toughness, long life, surface texture, which cannot be matched by the very best machine-made papers, whether American or imported. A good handmade paper will withstand a considerable amount of soaking, scrubbing and erasing and will age with little deterioration.

The weight (thickness) of watercolor paper is important. Thin papers should generally be avoided, especially for large work, since they buckle when wet and are inclined to

split if stretched. Weights vary from a light "72 lb." to the extremely heavy "300 lb." and, occasionally, even "400 lb."

Some papers are smooth; these are identified by the phrase, "hot pressed," or "HP." The more popular surfaces, however, have a grain or "tooth." "Cold pressed" or "CP" indicates a slight grain; "rough" or "R," a heavier tooth. These last two have an indescribably sympathetic texture, excellent to work on and pleasing to look at.

Watercolor papers come in several sizes, but the most popular is the "imperial," approximately $22'' \times 30''$. This is a convenient size for the average painting and it can be halved or quartered for sketches. Papers are also available in spiral-bound pads and in blocks that are convenient for sketching.

Mounting and Stretching Paper

It is possible to buy handmade paper already mounted but don't confuse it with the cheaper illustration boards which are not as responsive. There are also many experienced artists who like to work with unmounted paper. As a rule, however, it is more satisfactory to paint on stretched or mounted paper as it eliminates buckling and gives the artist more control over his washes.

There are many methods of mounting and stretching paper and you may want to try several before deciding which suits you best. The fol-

Figure 6. When stretching wet paper, be sure the frame is at least 2 inches smaller than the paper in both dimensions. The paper is tacked to the frame as shown here.

lowing are among the simplest and most practical.

For *mounting,* the paper selected should be of good quality, though not necessarily of heavy weight. First, it is dampened thoroughly with a sponge (or soaked in water) until limp; then it is pasted evenly all over the back with some water-soluble adhesive such as bookbinders' paste or diluted glue. After this, it is laid, paste side down, on heavy mounting board which has been previously dampened. Next, with a protective sheet of paper placed over it, it is rolled or brushed or scraped to force out air bubbles and promote uniform adhesion. A photographer's squeegee is useful in this connection. The whole is then weighted down where it can dry flat, perhaps between two drawing boards loaded with books. Blotting paper is sometimes laid over the mounting board to hasten the drying process. Leave it until thoroughly dry or the mount will buckle.

The simplest *stretching* process consists of pasting or tacking the edges of a wet sheet of paper to a wooden drawing board or stretching frame, causing the paper to shrink smooth and tight as it dries. (See Figure 6.) This sounds easy but takes something of a knack. Be sure that the frame is at least two inches smaller than the paper in both length and width or the paper may work

loose; and don't remove the finished painting from the frame until it has dried for several hours or it may wrinkle badly.

Other Equipment

Every artist soon develops his own preferences for certain ways of working and a particular assortment of tools and paraphernalia. Aside from paints, paper and brushes, however, the only other essentials for watercolor painting are a palette of some kind (a white dinner plate will often do very well), several cups or small pans for mixing washes and rinsing brushes, blotters, rags, a sponge pencils, erasers, a razor blade or pocket knife (all of these can be useful though you may not need all of them at all times), a drawing board or easel and a convenient place to work.

Getting under Way

Once you have assembled your equipment, you will find it helpful to spend some time becoming acquainted with it before undertaking your first painting. While there is no one best way of doing this, the following exercises afford a sound guide.

To begin, let's examine the several ways in which you can apply your watercolor paints to your paper.

Exercise 1: Line Work — First, lay your color on in what might be called a linear manner. In other words, you "draw" your color into place using strokes of your brush. These strokes may vary in width from hairline (A, Fig. 7) to an inch or more (B). They may also vary greatly in length and direction: long, short; straight, curved; wavy or irregular (C and D). Some lines may be sharp (C), some soft (E), some uniform, some graded (F), some broken (I and J). They may differ in color and in value. Such lines will also show contrasts of texture, these being determined very often by the surface of the paper you use. Try your hand at all these. Don't attempt to copy exactly those shown in Figure 7, but see how many different kinds of lines you can draw. Experiment with all of your brushes.

Exercise 2: Dry-brush Work — When doing the exercises mentioned above, you will find that if the brush is dipped frequently into paint which is liquid, the strokes will be sharp and clean-cut (G) — unless, of course, the paint is extremely pale. However, if the brush begins to run out of paint (or if the paint was originally thick), the brush strokes will be ragged and broken (K), particularly if the paper you are using is rough. These latter strokes and paintings developed mainly through their use are designated " dry-brush " work. Experiment with this technique and see what interesting effects it can suggest.

Though relatively few watercolorists paint entirely in dry-brush, many use it occasionally, particularly for the development of certain textures: rough building materials, the bark of

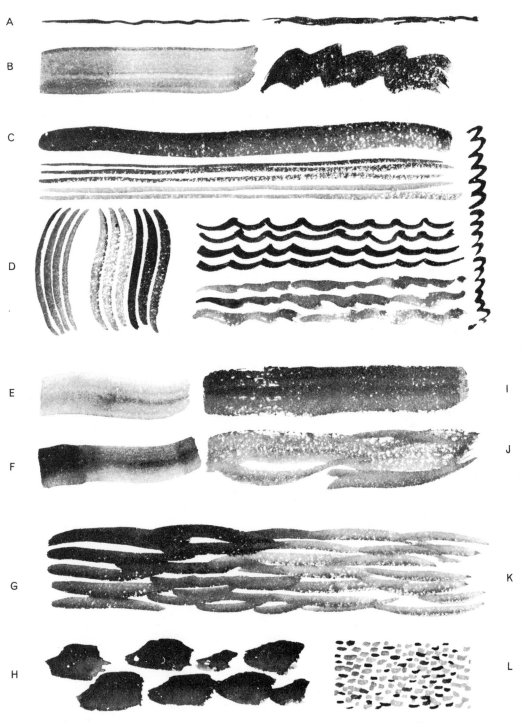

Figure 7. Examples of line work, dry-brushing, dabbing, and stippling.

trees, foliage and coarse cloth, for example.

Exercise 3: Dabs, Stipple — Instead of drawing with your brush, you can "dab" your color into place, merely touching the paint-laden brush to the paper again and again (H). By using brushes of different types and sizes and by varying your brush position or pressure, you can produce an amazing variety of brush marks.

Occasionally, artists paint some passages by using hundreds of tiny brush marks placed side by side in close proximity. This type of work (L) is called "stipple" or "stippling." By juxtaposing contrasting colors, a vibration or scintillation can be set up which is sometimes useful in obtaining atmospheric effects, appearances of distance, or suggestions of movement as in foliage. (For excellent examples of this technique, which is known as "pointillism," study the work of the French Impressionists.)

Wash Laying

In addition to the methods just discussed, there is another, wholly different but equally basic, watercolor technique — wash laying. The term "wash," as we use it here, means a mixture of any watercolor pigment (whether black, white, gray or colored) and water; also the tone which results from flowing such a pigment over the paper and allowing it to dry. The same word is also used as a verb to describe the act of applying pigment with this technique; in other words, we "wash" a given area.

Blacks and browns offer a good starting point for exercises in wash laying. (Incidentally, when we speak of a "wash drawing," we usually think of a watercolor drawing in one of these neutral tones.) Pigments with little sediment are the easiest to handle and produce washes of the greatest clarity and uniformity. In most makes, Lamp Black is good. Ivory Black generally has a bit more tendency to precipitate. Sepia is perhaps the most amenable of the browns. With these under control, you will be ready to try all your colors.

Exercise 4: The Flat Wash — Washes are of two kinds: flat (uniform) and graded (changing in tones by easy degrees). Fill a saucer about half or two-thirds full of water and stir in a quantity of the selected pigment until you have a mixture of medium strength. (Later try it thick and thin.) Dampen a sheet of stretched paper (or mounted paper, fastened to your drawing board) with plain water applied with your large sponge or brush. This preliminary, while not absolutely necessary, makes it easier to lay a good wash. Let the paper stand until the last vestige of shine has disappeared. Pitch your board at an angle of five or ten degrees from the horizontal. If too flat, the pigment will not flow properly; if too steep, the wash may get out of control, running from the board. Have rags or blotters at hand for such an emergency. Washes flow more freely on

smooth paper than on rough, and some pigments run more quickly than others. Pitch controls the speed of flow, thus affecting the character of the wash.

Now select a fair-sized brush (Number 7 or 8 is good) and you are ready to begin. (Avoid small brushes; they are intended only for detail.) Your first washes should be about five or six inches square. Boundary lines may be drawn, although it is easier not to be so restricted. Later, it is excellent practice to try filling exactly the penciled boundaries of squares, triangles and circles. Still later, practice on large areas. It takes considerable skill to control washes when you are painting a picture, so get all the practice you can.

Rinse the selected brush in water (cultivate the habit of doing so frequently); remove most of the water by touching the brush to cloth or blotter (or by " slatting " it toward the floor — an efficient measure not popular in the home!); dip it in the pigment (stir the color every time you do so) and lift it, ready to apply to the paper.

If you are right-handed, start the first stroke in the upper left-hand corner of the selected area. Hold the brush freely and naturally, much as you hold a pencil in writing (though with its angle varied according to conditions), and, sliding it along the paper lightly, paint a horizontal stroke the desired distance to the right. The object is to apply enough pigment so that an actual puddle will form along the lower edge of the stroke. If you fail in this, redip the brush immediately (don't forget to stir!) and apply a second stroke to the same area. This matter of obtaining a puddle at once cannot be too strongly emphasized. The beginner frequently uses so little pigment that it sets immediately, each brush stroke drying as a separate stripe. (See Figure 8.)

With the puddle formed, recharge the brush (stir!) and take a second stroke from left to right, the point of the brush just touching or slightly overlapping the lower edge of the puddle, which should flow down and form again at the bottom of the new stroke. Repeat this process over and over, gradually advancing the wash down the paper. You may not have to dip the brush for each stroke (the aim being to keep the wash, puddle and all, as uniform as possible), but always do so before the pigment is wholly exhausted. The larger the wash area, the bigger the puddle required.

Don't *rub* the paper with the brush; use a feather touch. The brush should merely convey the pigment to the paper and guide it, the wash flowing of its own accord. This is a fundamental difference between watercolor and oil painting; in the latter the color is normally brushed in.

As the bottom of the predetermined area is approached, add no new pigment, but carry the puddle down until it exhausts itself. If there is excess pigment remaining as the lower edge is reached, absorb it

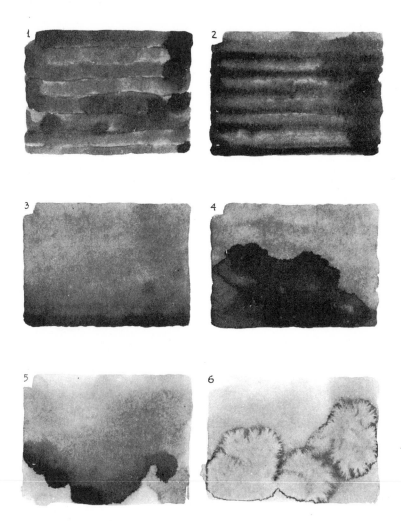

Figure 8. Some examples of unsuccessful washes are shown here. Wash Number 1 was run too dry with no puddle except at end of strokes. Although better, Number 2 lacked sufficient puddle and the pigment was not thoroughly mixed. If a wash is left too wet at the bottom, it may dry much darker there, leaving a graded effect as in Number 3 or it may cause "runbacks" or "fans" as in Number 4. If too much dampness is taken up along the bottom and the top is allowed to remain wet, an effect like that in Number 5 may result. "Fans," such as in Number 6, can be caused by accidentally dropping pigment on a drying wash. Always leave a wash alone until it is thoroughly dry.

with the brush, touching the latter to rag or blotter as proves necessary, or squeezing the pigment back into the saucer. Then watch the lower edge for a moment and if a new puddle forms, absorb it.

However faulty a wash may seem, *never work back into it until it is dry.* Trouble will almost certainly result if you do. It is far easier to learn to lay washes well than to learn to repair them when they go wrong.

Figures 8 and 9 show some typical faults; all but the last pair (5 & 6, Figure 9) can develop with flat washes. Study these with care. With a bit of practice you can learn to avoid most of these difficulties. Wire edges, however, like those surrounding the wash at 1, Figure 9, are a common cause of annoyance, resulting from gravity and capillary attraction. They are most frequent when heavy, settling pigments are used. The bigger the puddle and the slower the drying (as with the board flat), the greater the danger. If overconspicuous, dampen them carefully with a fine pointed brush (after they have thoroughly dried) until they can be absorbed with brush or blotter. Sketches 2, 3 and 4, Figure 9, point to the need for absolute cleanliness.

Paper insufficiently stretched, or not stretched at all, can also be troublesome if it buckles into a series of corrugations. The pigment particles slide down the hills into the valleys to dry, and the corrugated effect is evident even when the paper is flattened out again.

Alternate Methods

As pigments and papers vary in their characteristics, sometimes one manner of working is better than another. Experiment with various ways of laying tone. If a color tends to set too quickly, revealing horizontal strokes when dry, change your method by letting each stroke, overlap half, or even the whole, of the previous one. Or use a rotating (stirring) rather than a direct, motion of the brush.

If you find that a left-to-right stroke causes an over-accumulation of pigment at the right, as at 1 and 2, Figure 8, substitute a back-and-forth stroke. In short, use the method which produces the best results. The main thing is to keep an even distribution of pigment and to avoid the disturbance of pigment particles once they have set.

Exercise 5: Superposition — When you have acquired the knack of laying individual flat washes fairly well, with light, medium and dark pigments, even to the extent of placing them within definite boundaries, try running one wash over another which is dry, for this is a thing which you will frequently have to do in painting pictures. Unusual care must be exercised not to loosen the underlying pigment: both lightness of touch and reasonable speed are therefore essential. Some pigments, at best, are intractable in superposition. As you work, note the ones which give the greatest and the least satisfaction.

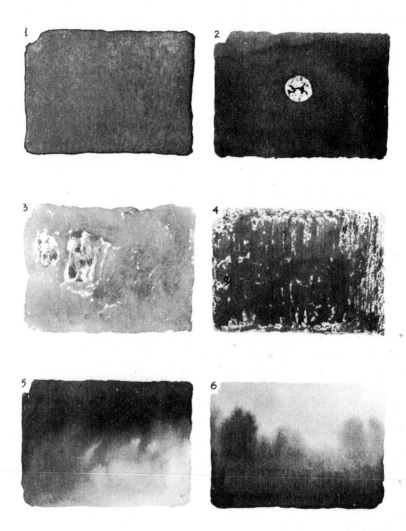

Figure 9. Here are more examples of unsuccessful washes. Dark edges as in Number 1 may result when a " settling " pigment is puddled on with the paper flat. In Number 2, an oil spot on the paper, invisible before the pigment is applied, ruined an otherwise good wash. Numbers 3 and 4 show the importance of keeping tools and materials clean. The trouble with Number 3 can be blamed on paper ruined by perspiration from the artist's hands. A dirty brush was at fault in Number 4. In Numbers 5 and 6, evenly graded washes were intended, but water and pigment were not added gradually enough. However, both washes do have interesting accidental qualities.

If you superpose washes of two or more colors, you will have your first contact, so far as these exercises are concerned, with effects of color mixture, for one color over another creates a third. We will learn more about this in later chapters.

Exercise 6: Graded Washes, Dark to Light — As most subjects can best be interpreted by washes which grade from dark to light, from light to dark, or from one color to another, our next step is to master the technique of applying graded washes. Let us start with grades from dark to light.

Form a puddle of dark pigment at the top of a predetermined area, just as for a flat wash. Your problem is to dilute this gradually as you guide it down the paper. If you dip your brush in water and apply it directly to the puddle of pigment, advancing the wash through repetition of this process, you will be likely to obtain a streaked result. The gradation may be too rapid, as it was at 5, Figure 9. (This wash, despite its failure to give the desired result, is highly interesting, the light portions seeming cloudlike.) Or too much of the dark pigment from above may follow down to prevent the desired lightness below. So practice until you acquire the knack of obtaining the necessary uniformity.

Here is one method: With a reasonably generous puddle of the selected pigment formed, dip your brush into your pigment and then into water, quickly blending the brushful of mixture on another saucer or

suitable surface (the edge of your paper will do); then immediately apply it to form the second stroke of your wash, merging the new mixture with the original puddle as it runs down. For this, a rotating (stirring) motion is best. Constantly repeat this process as you advance the wash, also absorbing superfluous dark pigment as it proves necessary.

Some artists vary this method by repeatedly adding water, between strokes, to the saucer of original mixture, keeping the whole thoroughly stirred; this is a good process. In still another method, favored for large or particular work, several saucers of the selected pigment are prepared ahead of time, varying uniformly in degree of strength. Washes are then applied in the proper order, each flowing gradually into the next, any excess of the darker pigment from above being occasionally absorbed. Try these grades with different pigments.

Exercise 7: Graded Washes, Light to Dark — It is considered easier to grade from light to dark than from dark to light. The former process is reversed. Start at the top with a puddle of pure water or light tint, adding darker pigment a bit at a time as you proceed, absorbing any excess of the light pigment. For important work, the previous preparation of several saucers of pigment of varying strength is recommended. The knack is to add the darker pigment so gradually that the final wash shows perfect gradation.

Exercise 8: Double Grades — Practice washes grading from dark to light and back to dark, and vice versa.

Exercise 9: Grading from Color to Color — Don't confine your attempts to a few pigments, but try all the colors in your box. Grade each from light to dark and from dark to light; then practice grading from one hue to another. Mix the two in separate saucers and start the wash with either, substituting the other by easy degrees. This is not only excellent brush practice but it gives you a vital contact with color mixture; it is fascinating to observe the birth of the resultant new colors. Also run washes grading from a given hue to water and then to a second hue. Washes showing gradation from color to color should be attempted, too.

Exercise 10: Two Colors At Once — By dipping one side of your brush in one hue and the other side in another, beautifully graded effects can often be formed by means of single strokes. The brush must be tried, of course, on practice paper. A flat brush is preferred. The method is at its best for quick sketching. See how well you can master this technique.

Never lose any opportunity of improving your dexterity in laying washes. Eventually, try all your pigments, papers and brushes, as well as different slopes of the board. Many otherwise expert painters have failed to master this trick and, as a result, are under a constant handicap which a few hours concentrated practice would overcome.

Oil — Equipment and Basic Techniques

Although oils are unquestionably a bit more cumbersome than watercolors — they are messier, take a long time to dry and are harder to clean up after, to name a few of their less attractive qualities — many painters feel their advantages far outweigh such minor annoyances. Oils are much easier to handle, for one thing. Whereas it requires considerable experience before one can hope to become skillful in controlling watercolor, the beginner working with oil paints is often pleasantly surprised at how easily he obtains attractive colors and textures. Further, he finds he can make any changes or corrections that seem necessary without difficulty and, if he wishes, can even scrape the whole painting down to the bare canvas and begin again.

Equipment

As with watercolor, one needs only a few things at the start, but these should be of the best. There is no economy in buying cheap paints, brushes or canvases, for you can't hope to do your best work with poor quality tools and materials. On the other hand, there is no need, at the outset, to buy everything in sight (although, if one can afford to, it is often tempting to do so). As you experiment and find your own way of working, you will gradually want to add certain items as you feel you need them.

Supports

The material on which a painting is made is called the "support." It is possible to paint on almost any kind of material or substance, but the usual support for an easel painting is canvas mounted on wood stretchers. There are, however, some artists who prefer a rigid support (as opposed to the resilience of stretched canvas) and they will usually choose a panel of plywood or Masonite or some similar material.

Panels of canvas mounted on composition boards of various kinds are also available. These are sometimes very convenient for outdoor sketching since they come in sizes that fit easily into the lid of a sketchbox. They vary greatly in quality, however, and even the best are not usually regarded as satisfactory for important work.

Artists' canvas is made of either cotton or linen and comes in various grades and textures. Cotton canvas, usually less expensive than linen, has a smooth, machine-made texture. The cheaper grades of linen canvas are often loosely woven and irregular in contrast to the evenness of the more expensive grades. Some artists like to paint on the smoother surfaces, but others prefer the textural irregularities of the cheaper linen. One's choice will depend largely on one's personal painting style.

Canvases already mounted on stretchers can be bought at most art supply stores, but many artists find it more convenient and economical to keep a supply of stretcher strips on hand and tack the canvas, which can be bought by the yard or roll, into place as needed. Any dealer will show you how to do it — it's no great trick. As to size, canvas measuring 17½ by 21½ inches will fit a 16- by 20-inch stretcher, allowing a 3/4-inch lap for tacking it to the stretcher. This is a good size for many purposes.

The kind of canvas normally stocked by art supply stores is already sized (often with glue or gelatin and water) and primed (generally with White Lead and oil) to form the painting ground or surface. Such canvas usually requires no additional preparation before the artist begins to paint on it. If, however, you should ever wish to use raw or unprepared canvas (the kind not ordinarily sold for artists' use), it would be necessary to size and prime it yourself in order to prevent the paint from soaking through. Detailed instructions on how to size and prime canvas and other kinds of support are available in several of the reference books on painting techniques already mentioned.

Brushes

The brushes ordinarily used for oil painting are stiff bristle brushes which come in "brights" — flat, thin brushes with short bristles, " flats " — thicker, with longer bristles, sometimes oval rather than square, and " rounds " — same length as flats but rounded, with pointed tips. (See Figure 10.) The springy, relatively soft sable brushes, which are ideal for the watercolorist, are employed in oil work only for fine detail, soft brush strokes and delicate blendings. They are made both flat and round, common kinds being short-haired brights, pointed rounds and flat longs.

Two other types of brushes are sometimes used by the oil painter. One, known as a blender, is soft

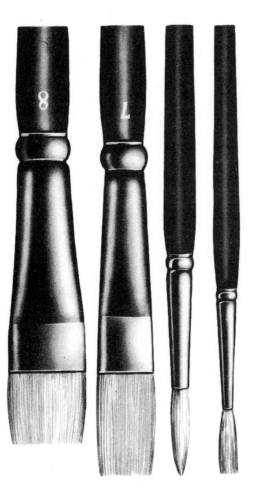

Figure 10. Bristle brushes are most commonly used for oil painting. It is helpful to have them in several sizes and shapes. Shown here from left to right are a Number 8 bright, a Number 7 flat, a Number 1 round, and a lettering brush.

and often large and flat (though blenders come in a variety of shapes and sizes); the other is an inexpensive brush (such as can be bought in any hardware store) for varnishing.

A typical selection of brushes for oil painting would include a few flat bristles (some with short hairs and some with long), ranging perhaps from Number 2 to Number 8; four or five red sables, some round and some flat, starting with Number 3 and running to Number 12 or 16

Figure 11. Stiff, trowel-shaped knives are well-suited for mixing paint. Straight, more flexible blades are generally preferred for applying paint to canvas.

(all should preferably have long handles); a couple of blenders measuring 1 inch to 2 inches; and a flat varnishing brush about 1 inch in width.

As you experiment with different brushes and discover which ones you prefer to work with, you may want to add several brushes of the type and size used most often. Some painters like to have a separate brush at hand for every dominant color in a painting. Others use one brush for light colors and another for dark. Such practices undoubtedly save time and paint. If only one or two brushes are used throughout, they will need very frequent wiping.

Care of Brushes

Brushes are rather expensive, so they deserve proper care. Never let paint dry in them. As you work, rinse each brush frequently in turpentine, kerosene or mineral spirits (or some similar solvent); then wipe it with a rag. At the close of a painting session, rinse each brush in the solvent even more thoroughly (excess paint can first be squeezed out on newspaper), after which you should wash it painstakingly with warm water (not hot) and laundry soap. Rub the brush on the soap and scrub it with a circular motion on the palm of your hand. Rinse. Then shape the wet bristles with the fingers — but don't squeeze! — and allow them to dry. Never stand brushes on their bristles.

Palette and Painting Knives

Some knives are used primarily for mixing colors on the palette. Others are used in place of brushes, or in conjunction with them, for the actual painting, conveying the paint to the canvas and spreading it in position. The type of knife selected depends on its intended use (see Figure 11). For mixing paint, a stiff knife — often trowel-shaped — is good. A wide blade aids in this manipulation. For applying paint, many artists choose a straight, more flexible blade, although preferences vary amazingly. Incidentally, never use your painting knife to scrape dried paint off your palette or you may ruin it. A putty knife is better for such purposes.

Palettes

As we have already indicated in Chapter 3, there are many types of palettes (objects on which the painter arranges his colors); the choice depends to a large extent on the working habits of the artist. The painter who likes to back away from his work frequently and then dash up for a few quick dabs, almost requires some type of thumbhole palette he can hold in his arm. Yet many painters, especially when working indoors, prefer a stationary palette. A sheet of glass, porcelain, plastic or painted wood laid on top of a table or artist's taboret is very convenient. Such a table-top palette leaves both hands free and is often

large enough to accommodate many colors, plus cups of thinning mediums, bottles of varnish, brushes, palette knives and other tools, which can be spread out ready for immediate action.

Whatever kind of palette is used, an important factor is its color. Many wooden palettes are finished in natural wood tones which are sometimes needlessly conspicious, making it hard for the painter to judge correctly the hues of his paints. It is better to use a palette finished in white or neutral gray. You can, of course, paint or lacquer any wooden palette to either hue. If glass is used — as on a table top — a sheet of white or neutral gray paper can be placed under it.

Thinning and Mixing Mediums

Paints, as they come from the tube, vary greatly in consistency. Some are excessively oily, others stringy and gummy; some tend to dry out quickly. For these and other reasons, artists sometimes mix their pigments with various types of thinners and mixing mediums. The most common is rectified turpentine — " turps " in the vocabulary of the painter. (Ordinary turpentine from the paint store is not satisfactory, however.) Refined linseed oil, sun-thickened oil and stand oil are other common thinning mediums (usually intermixed with turpentine, varnish or both). The proper use of these various mediums depends on so many factors that we can only recommend reference to the technical books already mentioned for those who wish to know all about this subject.

We should point out, however, a few of the more obvious things to keep in mind in using mediums. First, inasmuch as most tube colors already contain too much binding medium (in order to prevent deterioration in the tube), the amount of added medium of an oily nature should be kept to a minimum. Such a medium should also be simple in its chemical makeup. It would obviously be unwise to use too many substances in a picture because of possible ultimate reaction. In other words, a single medium should usually be employed throughout a painting unless one is an expert in such matters.

Incidentally, if the medium is varied from paint layer to paint layer, one should observe the old painting rule of " fat over lean. " This means that for the underlayers of the painting, the " lean " and quick-drying turpentine might be used, with more oil added in the upper layers (the same procedure house painters follow). But never reverse the process.

Speaking of turpentine, many painters rely overmuch on it. Employed to excess, turpentine tends to weaken paints with which it is mixed as it overdilutes the oily binders which hold the pigment particles together. Turps, being a solvent, also tends to dissolve any paint underneath. Too much turpentine causes painted surfaces to dry flat (dull) or to exhibit

alternate areas of dullness and gloss, according to the relative amounts of turpentine and oil present. Turps is best for underpainting and for *alla prima* painting done at one sitting.

An excess of linseed (or other) oil is about as bad as too much turpentine. Oily paints can prove sticky and slow drying, which can be especially annoying if they are used for underpainting which is to be gone over later with additional coats. Most oils also tend to darken gradually on exposure.

For these reasons, artists often mix half linseed oil and half turpentine as a medium. Another commonly used formula calls for thirds of turpentine, linseed oil and dammar varnish. Some artists substitute copal varnish for the dammar; still others prefer to buy one of several ready-prepared mediums

Driers

In order to speed up the drying of paintings, artists sometimes add to their paints small quantities of siccative. This must be used sparingly, however. Employed to excess, it is said to be very harmful, impairing the permanence of a painting. A drop of drier (preferably the type known as " cobalt ") to 2 teaspoonsful of your painting medium, plus a drop to each 2 inches of paint as squeezed from the tube, should be ample unless the atmosphere is unusually humid.

Certain colors dry more rapidly than others. In most makes, the earth pigments (such as the ochres and umbers) and the lead pigments (including Flake White and Naples Yellow) dry so quickly that they can serve as driers if you mix them judiciously into your other colors. Obviously, no siccative should be added to colors which dry well by themselves. Some colors, including most of the blacks, the Cadmiums and Vermilion, dry slowly. However, manufacturers often adjust such varying drying rates so that they are less extreme in some brands than in others and this makes it impossible to give any definite rules.

Additional Equipment

As you develop your own methods of working, you will quickly accumulate an assortment of paraphernalia you feel you can't get along without. For oil painting, an easel is essential; you will also need small cups to hold mixing mediums and solvents (for rinsing your brushes). Rags are practically indispensable for wiping your brushes and, dipped in turpentine, they can also be useful for wiping off faulty areas of a painting. Remember that paint and oil-soaked rags are higly inflammable, so dispose of them accordingly. If you are working indoors, a painter's dropcloth or its equivalent can save a lot of trouble and worry. Artists' smocks are also useful for protecting your clothes. Finally, a paintbox — or sketchbox, as it is usually called —

is a handy way of carrying your equipment for outdoor work and can also serve as a convenient storage space in your studio.

Brush and Knife Exercises

Once you have selected your canvas or panel and set your palette, you have only to pick up some color on your brush or knife and begin to paint. It's as simple as that. Of course, how you hold your brush or knife and the manner in which you apply paint to canvas can make a very great difference in the kind of picture you will paint. But there is no one approved way and artists tend to be even more individual in their painting habits than in their handwriting

Some artists — although not very many — like to work in a very detailed manner. They may work sitting down, choose small canvases and use fine brushes, holding them like pencils, close to the metal ferrule. Where even greater accuracy or small detail is desired, an artist may use a maulstick as a hand support.

Many painters, however, disapprove of such practices, preferring instead a less labored approach. They believe that it is better to paint on their feet, using a rather long-handled brush grasped at or near the small end. This allows them to see the painting as a whole and execute it with freedom, speed and breadth.

You will, of course, eventually find the way of working that suits you best. In the meantime, it is well to beware of one especially bad habit that painters sometimes fall into at the beginning and later find very hard to break: staying too close to your painting as you execute it. When you work too close, your eye tends to focus on a few square inches at a time, with the result that you may be tempted to overdevelop this limited area, and then the next such area, thus losing the bigness of conception and boldness of execution without which a painting is usually doomed to failure.

As a preliminary to painting a picture, it may be helpful to experiment with your brushes and knives to find out what kinds of lines, tones and textures you can produce with each one. Examples are shown in Figure 12. Squeeze out four or five colors on your palette. Use the paint just as it comes from the tube for these exercises unless you find it unworkable, in which case you can add a minimum of medium. You might choose White, Burnt Umber, Ultramarine, Cadmium Yellow and Alizarin Crimson for these experiments; such an assortment will give you a wide range of hue and value, but any colors will do. The important thing here is not the way the colors combine (this will be discussed later on), but the way you can use your tools to achieve particular tones and textures.

Exercise 11: Lines — With each of your brushes, in turn, carry some

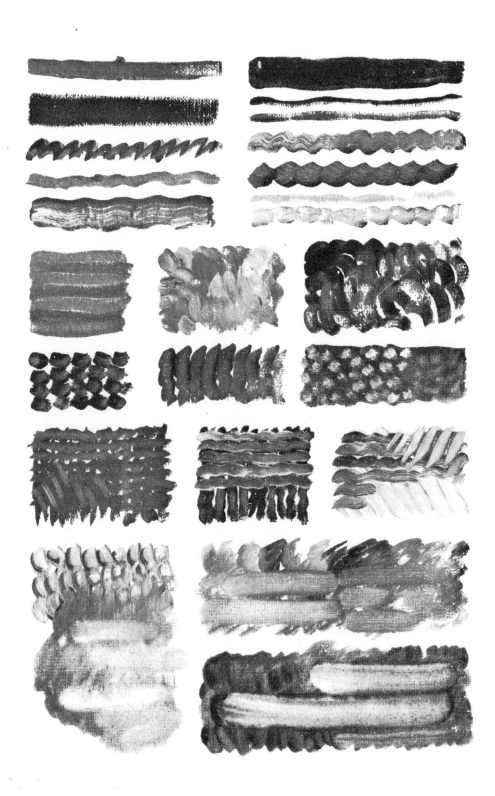

single strokes across your canvas, similar to those at the top of page 58. Use paint generously. Don't be disturbed by the ridges of paint which may squeeze out along the edges of a stroke, or by the way the line breaks

and lets some canvas show through as the brushful of paint becomes exhausted, giving the result known as "dry brush." These effects are characteristic of oil painting and often are created intentionally. Do some lines with the flat sides of your brushes, others with the thinner edges. Try light paint, medium paint, dark paint. Tip the bristles at different angles to the canvas. Vary your

Figure 12. Experiment with your brushes and knives to see how many kinds of lines, tones and textures you can produce. Examples are shown here and on the previous page.

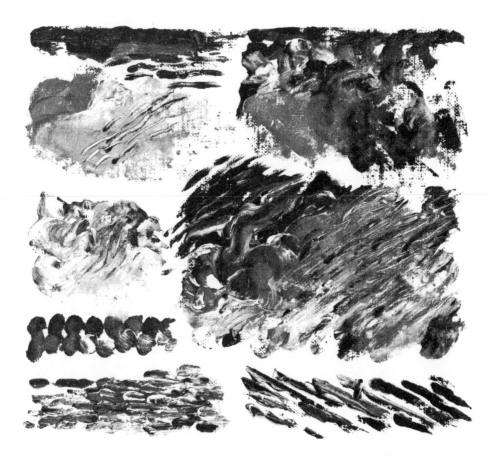

pressure. Make wavy lines, broken lines, zigzag lines. Invent lines of your own. Ultimately, you will need them all. As you work with your brush, you may find that you will want to turn it over, or up on edge, every little while in order to use the paint which accumulates. That's all right, too.

Exercise 12: Broken Color — Now dip your brush into two or more colors at a time and draw a number of lines again. As you paint, these colors will automatically blend somewhat, yet each will remain visible in places. Accidental effects obtained this way can be telling at times.

Exercise 13: Tones — Since most painting is tonal rather than linear, experiment with various ways of combining brush strokes to fill areas with tone. Let long straight lines slightly overlap. Or crisscross some strokes, perhaps brushing them out later into comparatively uniform tone, possibly with small bare areas of the canvas showing between them. In brief, combine short straight strokes, short curved strokes, short wavy or broken strokes; then do longer strokes having similar variety. Make some smooth, uniform tones. Grade some tones from light to dark; some from dark to light; some from one color to another, in each case striving for a uniform gradation. Paint light lines or dots into dark areas. In other words, be inventive.

Exercise 14: Dabs or Blobs of Color — Tones are often built up by merely touching a paint-laden brush to the canvas repeatedly to "print" many dabs of color side by side. These may or may not overlap. Often several colors are used in this way, the different colors more or less intermingling, but each still retaining something of its original hue.

Exercise 15: Thinned Paint — For early work on a canvas, the paint is often considerably thinned (usually with turpentine) for laying the foundation (underpainting) for the work to follow. The paint must not, of course, be thin enough to run, but it can approach that state. Experiment with paint thus diluted with turpentine to different consistencies. Then thin some with oil instead of turps so as to get the feel and appearance of both types of paint. Next try a medium of half turps, half oil.

Exercise 16: Wiping Off — If a certain passage fails to "arrive" when you are painting a picture, it is best not to fool with it too long. The usual procedure is to scrape it with a palette knife or wipe it off (in whole or in part) with a paint rag. Your index finger shoved into a folded rag is a good tool for this. Just use the rag-covered finger like a brush (perhaps dipping it into turpentine first) and wipe into the offensive area.

Paint a few areas and then experiment with them in this manner, wiping some of them away entirely and leaving others to paint over again later. These wiped lines sometimes become a part of the final technique.

Exercise 17: Knife Painting — Now

use your painting knives much the same as you have your brushes. Draw wide lines with the flat or the point of a knife, fine lines with its edge. Dab on blobs of thick paint. Use a knife as a spreader to cover large canvas areas and as a scratcher or scraper of tone already in place. In short, try everything which comes to mind, remembering that, as with your brushes, every trick which you learn now will have a thousand later applications. Your knives may seem clumsy tools at first, but with practice they can become amazingly fast and effective.

Exercise 18: Painting into Dry Paint — Much work is painted " wet-in-wet, " the artist completing a picture at one sitting. This is known as *alla prima* painting. Often, however, it is necessary or desirable to come back to a painting the next day or several days later, or even on many different occasions. This means painting into areas which are already partially dry. The effects which result are likely to be quite different from those painted in any other way.

As an experiment in this direction, coat some fairly large areas with different tones and let them dry partially. In a day or two — or even in a few hours — paint back into them. If such areas are quite dry, by the way, they often receive subsequent brushwork more sympathetically if they are first coated with a bit of medium or retouching varnish. This is especially true if they have dried flat and dull. The medium or varnish may be sprayed on with a fixative blower.

And now, having gained some experience in handling brushes, knives and paints, we are ready to return to the subject of color itself, particularly in relation to pigments.

Getting to Know Your Pigments

Once you have gained some control of your pigments (through the exercises recommended in the previous chapters), you should make a concentrated effort to learn their individual characteristics, investigating the behaviour of every color in your box until you know just what to expect of it; how it will look at full strength, mixed with white and black, thinned with medium (if oil) or water (if watercolor); its relative transparency or opacity; its amenability to application; and any special characteristics that may make its use more-or-less desirable for some particular purpose.

The exercises in this chapter are designed to help you gain this necessary familiarity with watercolor and oil pigments. (Similar exercises could be carried out for pastel, casein, ink or any other color medium you may wish to work in.) If you perform these exercises thoughtfully and neatly with the idea of saving the results for future reference, you will find they can be of great value.

Exercises with Watercolor Pigments

Although these exercises can be performed on other types of watercolor paper, a half-imperial sheet of cold-pressed Whatman board is a good size (15 by 22 inches), has a good surface to work on, and is in a convenient form for storing for reference. In some cases, several exercises can be done on one half-sheet.

Exercise 19: Hue, Name, Characteristics — Draw a series of small, vertical rectangles (2 by 4½ inches is a good size) on a half-sheet of cold-pressed board. (Allow a rectangle for each color in your box.) Now fill each rectangle with a different color wash, grading from almost pure color to the strongest color of which the pigment is capable. For comparison, group together the reds, yellows, blues, etc., just as you have them grouped on your palette. Write in the name of each color and, from time to time, add written notes as

you learn more about the individual characteristics of the various pigments.

With such a chart at hand, you can see at a glance the hue and intensity of each of your colors in both light and dark values; hence its value as a reference. Try to store up definite mental impressions of the results, so as to have in mind just what every one of your pigments can be called upon to do.

Exercise 20: Overlaying Bands of Color — Lay out a large square on the upper portion of a half-imperial sheet of cold-pressed board and rule it off in bands, allowing a vertical and a horizontal one for each pigment. Narrow bands of separation should also be provided to make the contrasts more emphatic. Brush full-strength flat washes of each color from top to bottom. When they are dry, brush similar washes across the sheet, giving a plaid effect. (See Figure 13 for guidance.)

As you perform this exercise, you will learn that many new hues can be created by overlaying your pigments. You will also see that some of your pigments can be washed over to advantage while others cannot. You will note, too, the relative transparency of your pigments. You can always turn to this chart as a reminder of the characteristics of any given hue when laid over another hue. If you wish to see what pigment or pigments will give a desired hue, you can hunt on this chart until you find an approximation of it. You can

then readily ascertain its component parts.

In this connection, make a "finder" by cutting a small hole through heavy white paper or cardboard. By looking through this hole, you can single out any individual hue on the chart and study it without the distraction of neighboring colors. It is helpful to get into the habit of making comparisons of your colors with white because, in watercolor work, colors are generally viewed and judged against a white background.

Exercise 21: Test for Opacity — In doing the previous exercise, you will find that some pigments hide the washed-over color more than others. As a further test for opacity, draw a ruled line of waterproof black ink across the sheet and, when it is dry, extend each of your vertical washes to cover it, as in Figure 14. You will note that, even though your pigments are of the so-called transparent type, some will prove quite opaque. Obviously, if such pigments are washed over others in a painting, they will tend to obliterate them.

Exercise 22: Test for Water Resistance — Scrub washes of all of your pigments with a wet bristle brush — after the washes have thoroughly dried — to test their resistance to water (see Figure 15). This will tell you which of your pigments are best suited for foundation washes over which you can safely superpose others. (Incidentally, if you should ever desire to work with absolutely waterproof pigments, you can turn

Alizarin Crimson
Rose Madder
Vermilion
Light Red
Burnt Sienna
Gamboge Yellow
Cadmium Yellow
Naples Yellow
Yellow Ochre
Raw Sienna
Cadmium Orange
French Ultramarine
Cobalt Blue
Prussian Blue
Phthalo. Blue
Cerulean Blue
Emerald Green
Sepia

to colored inks such as those put out by Higgins. These inks can be applied with brush or pen.)

Exercise 23: Another Method of Making Overlays — In addition to overlaying bands of color as suggested in Exercise 20, you can also draw widely separated washes of individual colors, crossing each with short washes of all the other pigments in your box. You may find this method easier to handle. (See A, Plate 2.)

Exercise 24: Crossing Pairs — Some students prefer to experiment with overlays by crossing single pairs of colors. (See B, Plate 2.) Of course, many such crosses would be necessary to provide every possible combination.

Exercise 25: Order of Overlaying — The importance of the order of overlaying is shown in the following experiment. First, cover a small area with a wash of Gamboge Yellow. When dry, brush French Ultramarine over it, extending the blue far enough

to permit a second wash of Gamboge to be laid over it when it is dry. The blue pigment will thus be laid over and under the yellow. You will find that while the blue flows over the yellow with little damage, the yellow crossing the blue streaks it. (See C, Plate 2.) This is one of the problems that can cause muddy color in your paintings so you will be wise to repeat this exercise with many pairs of pigments until you become familiar with all such quirks.

Exercise 26: Overlaying Several Colors — You can also superpose three or more hues, crisscrossing as many bands as you can. (See D and E, Plate 2.) However, if you perform such an exercise, you will quickly discover that neutrality or " mud " usually results from overlaying many washes of different hues. This points to the advisability of working as freshly and directly as possible when you are painting pictures. Mixture of pigments on the palette or in the saucer usually produces clearer results than overlaying.

Exercise 27: Color Mixing — One method of direct color mixture is to run two washes together while they are wet to form a mixed wash on the paper. To learn the possibilities of this technique, make many " Y " washes like those shown at F, Plate 2. Merely form a puddle of any desired color with one brush and, near it, a second puddle of another color, using another brush or the first, hastily rinsed. Then run the two puddles together, either in a wash,

77. Fig. 13, 14, and 15. In the top chart, each color is combined with every other color by overlaying bands of flat, full-strength washes. Below, the vertical washes were extended over a line of waterproof black ink to test the relative opacity of each pigment. The bottom chart shows the water resistance of each pigment. The washes were extended further, allowed to dry, and then scrubbed with a wet bristle brush.

as at F, or, better, blended with a rotated brush as at G. Thus you will show plainly a pair of colors and a resultant mixture. You can also mix groups of three and four colors, as at H and I. Such experiments should be saved for future reference with the names of all colors noted. The white paper or cardboard finder described previously is useful in analyzing these mixed hues.

Exercise 28: Minglings — Another useful approach to direct color mixture is the "mingling." This consists of making a partial mixture of two or more pigments so that they produce, in a comparatively small area, a maximum variety of hues, values and intensities. For this exercise, wet a rectangular area (about 3 by 4 inches) in the upper left-hand corner of a half-sheet of watercolor paper or board, which is laid flat. Definite boundary lines are unnecessary. Shake a few drops of any two intense pigments into this very wet area and allow them to spread. Manipulate them with the brush so that they retain their full strength in some places, while in others they blend quite freely or are greatly diluted. Part of the paper should remain white. Tipping the board slightly or blowing the pigment in the desired direction will help you in controlling the results.

Try another mingling of the same colors and scrub it when dry to produce softer tones.

Repeat this exercise with many combinations of two, three or more colors. Many of the effects achieved this way will surprise you and will suggest a variety of color schemes; this will be discussed in detail in Chapter XI.

Exercise 29: Test for Fading — To learn about the resistance of your pigments to bright light, you can, of course, refer to the manufacturer's catalogue. It is interesting, however, to test them for yourself. On a sheet of watercolor paper (not board) carry a pair of broad, single brush strokes of each available pigment from side to side, one in full intensity and one diluted. When dry, cut the sheet vertically into four strips. Every color should appear on each strip in full strength and as diluted. Write the names of the colors on at least one strip and the date of the test.

Place one of these strips in sunlight, perhaps at a window, another in bright light but away from the sun, a third in a dark corner, and the last where no light can penetrate. After a year or so, bring them together for comparison. Colors which prove the least permanent can then be rejected for serious work. The beginner can rest assured, while awaiting the outcome of this test, that, so far as his student work is concerned, any of his pigments will be sufficiently light-proof, unless placed for some time in direct exposure to bright sunlight.

Exercises with Oil Pigments

These exercises may be done on any white canvas of convenient size. It need not be of high quality. Save

each exercise and keep it handy for future reference.

Exercise 30: Hue and Name — Squeeze onto your canvas a bit of each color that you have, spreading it about with your palette knife or brush to cover thoroughly an area measuring a square inch or more. (It will prove convenient, for ease in comparison, if you group your areas of red, yellow, blue, green, brown, etc.) Next to each area, write in pencil the name of the color so that you will quickly learn to associate each hue with its correct name. Try to form a permanent mental image of both hue and name so that whenever you want some of this color, you will know it well.

Exercise 31: Drying Tests — Some paints dry much more rapidly than others. It is helpful to gain at least a general idea of the surface drying qualities of every one of your paints. Therefore, every few hours test with your finger each painted area used for Exercise 30. Add penciled notes to indicate which colors prove quick, medium and slow to dry.

Exercise 32: Tints — As we have already learned, a tint is a hue of color lighter than normal. In oil painting there are several ways to obtain tints on your white canvas. Try them all. (1) Dilute each paint with turpentine or other thinner. The more thinner you add, the lighter the tint will become. The color will gradually change from opaque to translucent and, eventually, will become almost transparent, allowing the light canvas to show through more and more as the thinner is added. (2) Brush the paint so thin that the canvas shows through clearly. (3) Blend in some white paint. Try this with your palette knife as well as with your brush. (4) Add light paint of some other color. (Of course, when you do this, you will not only create a tint, you will also change the hue.)

Exercise 33: Shades — Whereas a tint is a hue of color lighter than normal, a shade is a hue of color darker than normal. You can obtain shades by adding black paint in varying degrees to your normal colors. (You can add darks of other hues, but of course they will modify the original hue somewhat.)

Mix each of your colors with varying amounts of black to produce a series of shades. Mix some of them with darks of other hues and note the changes.

Exercise 34: Charts of Normal Colors, Tints and Shades — Now that you have experimented rather freely with all your colors, it will be helpful to make a chart showing all the gradations that are possible by mixing one color with white and black, as shown in Plate 3.

Paint a row of squares (an inch or so in size will do) horizontally across the middle of a canvas, one for each of your colors just as it comes from the tube. Above this row, paint a second row of squares in which every color is considerably lightened by the addition of white. This will give

you a series of tints. Above this, add a third row in which the colors are still further diluted with white, creating even lighter tints. Above this, add a fourth row (more if you wish) containing constantly increasing amounts of white.

Now for some shades. Below the original row of normal colors, paint a second row, with each color somewhat darkened by intermixing black; below this, a third row with each color greatly darkened. You may want to add a fourth and perhaps a fifth row of still darker shades.

You will now begin to see what a variety of colors is obtainable by even this simple mixture of white or black to each of your normal colors. Some interesting comparisons will also be evident. For instance, you will observe that normal colors vary greatly in value, some being quite light and others quite dark. For example, yellow in its normal form is very light in value — practically a tint in itself. Therefore, as you add the white to yellow to create a series of yellowish tints, these will vary only slightly from one to another. On the contrary, in the case of a paint which is normally dark — deep blue or violet, for instance — as you add the white you will discover a very noticeable difference from area to area. Therefore, whereas a light tint of yellow will look quite similar to the normal yellow paint, a light tint of deep blue or violet will look very different from the normal deep blue or violet.

Now study your areas of shades. Here the yellow will seem to change very rapidly in hue as the black is added to make it darker. The chances are that a dark shade of yellow will have an appearance which you would scarcely call yellow at all; it has a greenish tinge. In the case of the dark pigments, there will be far less differences in your shade squares.

Another thing you will notice is that some pigments which appear very similar at normal strength may seem quite different when mixed with white. Note, for instance, the distinct difference that are apparent in the tints of two or three deep blues and two or more strong reds.

Try to get all such differences in mind so that, if you wish to represent a certain tint or shade in a painting, you will know just what paint will give it to you through the addition of white or black only.

Exercise 35: Colors Thinned with Medium — You may also find it helpful to make somewhat similar charts showing what happens as each of your colors is thinned with varying amounts and kinds of mediums. Try small quantities of turps or oil first; next dilute the paint a bit more with a half-and-half mixture of turps and oil; then try a mixture of thirds of turps, oil and dammar or copal varnish. If you do this with all your pigments, you will learn a good deal about the relative opacity or transparency of each color. Those which have a high degree of transparency — you will find that Alizarin

Crimson, Viridian and Ultramarine are in this classification — can be particularly useful as glazing colors.

Mixing Colors

As you experiment with your pigments, you will quickly discover there are many ways of mixing colors. There is no best way; all are useful at times. The important thing is to become familiar with the effects that can be obtained by each method.

Exercise 36: Blending — First, squeeze out a small amount of any color and, 2 or 3 inches away, a small amount of any second color. Then, using a stiff bristle brush or a palette knife, bring the two colors together on the palette and intermix them thoroughly until they blend to produce a third color. See Plate 4.

To extend this experiment further, squeeze out a bit of white and a bit of black, in separate dabs 2 or 3 inches apart and an inch or two below the blended mixture just created. Now mix the new color with the black and with the white. Thus, you will not only see what the two original colors will yield, through admixture, in the way of a third color, but you will discover how this third color will appear in a full gamut of values ranging from light tints to dark shades. Repeat this exercise with many pairs of paints. (You can carry this exercise even further, experimenting with mixtures of three or four paints.)

Exercise 37: Combining — A com-pletely different, and often much livelier, effect can be achieved if, instead of blending the colors together on the palette as in the previous exercise, two or more colors are picked up together on the brush or palette knife and applied directly to the canvas. See Plate 4. Try this with many pairs of hues; then try it again, adding white as a third pigment. Compare the results with those achieved in the previous exercise.

Exercise 38: Glazing — When a transparent color is glazed (brushed thinly) over an underpainting (or ground) of an opaque, usually lighter, color, the color of the underpainting merges or blends with that of the glaze, creating an optical effect quite different from the color mixtures already considered. See Panels 1 through 7, Plate 5. In carrying out Exercise 35, you discovered that some colors — Ultramarine, Alizarin Crimson, Viridian and Burnt Sienna, for example — are especially transparent. Now try glazing these and other semi-transparent pigments over opaque grounds of various hues. Be sure that the underpainting is thoroughly dry first; then, just before applying the glaze, moisten the ground very slightly with the painting medium. The glazing may be done with a painting brush, a blender or a dauber of cheesecloth lightly loaded with paint which can be tapped or stroked on the underpainting.

Exercise 39: Scumbling — This term generally refers to the daubing of an

opaque color (usually lighter) over another color (usually darker), giving an uneven, broken effect. See Panels 8 and 9, Plate 5. As with glazing, it creates optical color mixtures that can be most interesting and effective. Scumbling is sometimes used to veil or tone down passages that are obtrusive or overworked. Experiment with this technique, using your darkest colors for the grounds and light opaque pigments such as White, Yellow Ochre and the Cadmium Yellows and Light Reds for the scumble. The underpainting, which may even be isolated with a coat of varnish, should be dry to the touch. The paint used for scumbling may be brushed on and partly wiped off or it may be rubbed on with a brush, rag or finger; occasionally it is stippled. Investigate all these methods.

Texture

Although, as we stated in Chapter II, texture is not an inherent quality of color, it has an undeniable relation to the way we see color and is of vital importance to everyone who wishes to use color effectively.

The painter whose work is primarily representational has various ways of using texture. He can employ his pigments in such a way that they indicate the textures of the objects in his painting; he can use his pigments and the tools and techniques at his command to create textural effects that are interesting in themselves; or he can do both.

Plate 3. (See page 35.) Mix your normal pigments with white to produce tints, and with black to produce shades. The top row shows pure colors — Cadmium Red, Cadmium Yellow, and French Ultramarine. In the second and third rows, white has been added; in the bottom row, black. Note that the yellow mixed with black shifts toward green.

Plate 4. (See page 36.) Oil pigments thoroughly blended on the palette present a rather smooth, flat appearance. The same pigments picked up together on the brush or palette knife and applied directly to the canvas, combine in a completely different, livelier way. In Panels 1, 2, 3, 6, 8, and 9, two pigments are shown thoroughly blended on the left, and combined with white on the right. In Panels 4, 5, and 7, the combined colors are brushed out over the blended undertones on the left.

It is not the purpose of this book to tell how to paint particular textures. However, if the reader will experiment with his pigments as suggested in the following exercises, he will find many new ways of achieving textural interest which he can easily adapt to his paintings as he finds need for them.

Exercise 40: Surface Textures — The surface on which you paint, whether it be paper, canvas or some other type of support, plays a great part in texture representation. Brush the same pigment mixture over areas of several different types of watercolor paper (see top row, Plate 6) and you will find that, even though you use the exact same color on all of them, the results will appear quite different, depending on the smoothness or roughness of each paper's surface.

A similar experiment can be performed with oil colors. Try it, using coarse canvas, fine canvas, canvasboard, Masonite, plywood or similar surfaces as your supports. In actually painting on some of these materials, you would normally cover them first with a ground coat of White Lead or some other light color, but for this experiment try some areas without the ground coat and see how both color and texture are affected.

Exercise 41: Pigment Textures (Sediment Washes) — In performing many of the previous pigment exercises, you doubtless discovered that pigments themselves vary in textural characteristics. It is to your advantage to continue experimenting along this line until you have all such peculiarities well in mind. This is particularly true for the watercolorist who *must* learn which pigments give clear washes and which give the type of washes known as " sediment, " " settling, " " deposing, " "granulated " or " precipitated. " Though these sediment washes are disastrous when not wanted, they produce textural effects that are extremely useful for many purposes. (See Plate 6.)

Sediment washes can be employed alone, in mixture, or overlaid. In combination, they often develop far more sediment than when used singly, especially when both pigments tend to depose. Burnt Sienna and French Ultramarine, in particular, are capable of producing astonishing granular effects (Panels 7 and 10, Plate 6.) Even smooth papers may look rough when this combination is applied. If your drawing board is kept flat, or nearly so, while such washes are run, the separation of the pigment particles is likely to be increased. Sometimes, to secure the desired effect, the board must be rocked back and forth. Experiment with such methods until you know how to control sediment washes to achieve this texture when and where you want it.

Exercise 42: Methods of Application, Including Some Special Tricks — The most usual methods of achieving textural effects are suggested, however briefly, in Chapters IV and V,

dealing with the basic methods of applying pigment to paper and canvas. Much can be accomplished by such relatively simple, direct means, but some artists prefer to "play around" with their pigments and tools, looking for happy accidents which can be repeated when they want a particular effect.

The oil painter has an unlimited number of working methods open to him and each offers its own range of textural effects. He can, for instance, thin his paints with a considerable amount of medium and use them much as he would watercolor washes, letting the texture of the canvas become part of his painting. Or he can use his pigments just as they come from the tube, applying them thickly with palette knife rather than brush and building up an impasto that has an actual three-dimensional quality. He can apply his paint in layers, glazing, scumbling, varnishing; wiping off, painting over; using knife, brush or whatever to create the textures he is after. (See Plates 4 and 5.)

Watercolor, although it is usually considered a more direct medium, less amenable to experiment, nevertheless offers many opportunities for unusual textures as the examples in Plate 7 reveal. If you are working on a heavily grained surface, for instance, striking results can be obtained if the "hills" are scrubbed, erased, sandpapered or otherwise lightened as in Panel 1. A razor blade or knife can also be employed, either before or after the pigment is applied, as in Panel 2 which shows an area which was painted, then scratched, then superposed with other colors.

Such mediums as wax crayon, charcoal and india ink are sometimes used in conjunction with watercolor for unusual textures that could never be achieved with watercolor alone. Panels 5, 6, 7 and 9 show some of the many ways crayon and watercolor can be combined.

A rather unique method is shown in Panel 8. Here, the crumbs resulting from ordinary erasure were sprinkled on the paper and a mixture of Burnt Sienna and French Ultramarine floated over them. When the wash was dry, the crumbs were brushed away. This trick is very effective in representations of antique stone fragments; by adding Emerald Green, marvelous suggestions of oxidized copper or the encrusted patina of ancient bronze can be obtained.

Try all these methods and others of your own invention. There is no better way of extending power over your medium.

Scrubbing

A word more about scrubbing. Not only are occasional washes scrubbed for the development of texture, but entire watercolor drawings are frequently developed by the "scrub" method. Usually the surfaces (smooth paper is popular) are washed over with brilliant pigments (the scrubbing being anticipated),

and when thoroughly dry they are scrubbed in whole or in part with a sponge, rag, or a bristle brush. After this they are touched up by means of thin washes and a few accents here and there. Some artists repeatedly wash down and build up, taking their drawings to the sink if necessary. Even soap is employed if certain colors are too resistant. Others work more delicately, merely dampening and blending their colors with a soft brush, or picking out highlights. Beautiful effects are produced by such methods.

Unique Methods

Plate 8, which explains itself quite well, opens further fields for experimentation with watercolor. The student should explore these, later applying the various tricks as occasion arises. The upper row of rectangles demonstrates to what extent such mediums as crayon, charcoal, and ink are sometimes used in conjunction with watercolor. Charcoal and soft pencil are customarily sprayed with fixatif before the washes are applied.

Just now we wish to emphasize what is known as "broken" color, for in its use we discover a new means of pigment application. If we turn to nature for color inspiration we find comparatively few areas of flat, solid color. Practically everywhere we see an astonishing variety of both hue and texture. Paintings must frequently show like variety.

Plate 5. (See page 37.) Wonderful effects of color mixture can be created in oil by brushing thin glazes of transparent color over light opaque underpainting as in Panels 1 through 7, and by scumbling light opaque color over darker underpainting as in Panels 8 and 9.

Plate 6. (See page 38.) Certain pigments and papers lend themselves to interesting textural effects. In the top row, Panels 1 through 5 show different surfaces painted with the same wash mixture. Panels 6, 7, and 8 show typical sediment washes, alone and in mixtures, on rough papers; Panel 6 is a wash of Vermilion; Panel 7, Burnt Sienna and French Ultramarine; Panel 8, Raw Sienna and Cerulean Blue. In the bottom row are examples of overlaid washes: Panel 9 shows Emerald Green over Rose Madder; Panel 10, French Ultramarine over Burnt Sienna; Panel 11, Cerulean Blue over Light Rose Madder.

Plate 7. (See page 39.) A variety of special textural effects can be achieved with sandpaper, knife, and white wax crayon. 1. A sediment wash was applied to a rough paper; then part of it was sandpapered. 2. The first wash was scratched with a knife and glazed with a second wash. 3. The first wash was sandpapered and then glazed with a second wash. 4. The paper was scratched with a knife before any pigment was applied. 5. Lines of white wax crayon were drawn before the washes were laid. 6. Both knife and crayon were used under the washes. 7. Before the washes were laid, wax crayon was applied evenly so that it hit the tops of the elevations on the rough surface. 8. A sediment wash was laid over eraser crumbs. 9. A sediment wash was glazed over crayon, then sandpapered.

Often the artist takes advantage of the roughness of his paper to "break" his color with little spots of white, as demonstrated at 1, Plate 8. By combining various colors thus broken with white, pleasing effects are obtainable.

Panel 2, Plate 8, shows broken color applied in a unique manner, for a damp brush was dipped in (or, rather, touched to) red and blue pigments simultaneously, and then so stroked across the paper as to leave whites here and there. In Panel 3, two brushes were dipped separately and then used together, held with the ferrules touching. This trick is convenient when painting grass, waves, etc. Panel 4 pictures the employment of dabs or crosshatch of color. For occasional problems this technique is splendid.

Panel 8 shows us an unusually interesting example of broken color done with a small sponge dipped into several hues at once. The paper was rough. In similar effects, known as "dry brush" work, a brush not too full of paint is substituted for the sponge. In Panel 6 we have a still different type, a brush, previously touched to several colors, having been rolled along with its point in contact with the paper. Architectural renderers sometimes represent marble in this manner. At 7 we see another application of the same method, this time with a single color. Stipple is of many kinds; Panel 5 pictures a typical example. Panel 9 offers a less common but very rapid type.

Plate 8. (See page 40.) Watercolor combines well with other mediums, as shown in the top row of panels. Illustrated from left to right are combinations of watercolor with dark crayon, colored pencil, black pencil, and colored ink. Examples of various broken color techniques are shown in the panels below: 1. rough paper; 2. two hues on brush; 3. two brushes together; 4. dabs or crosshatch; 5. stipple; 6. rotated brush with several colors; 7. rotated brush with one color; 8. striped with sponge; 9. stippled with sponge.

Making and Using Color Charts

As stated before, the various systems of color measurement, useful as they are in some industries and in certain areas of the applied arts, have only limited value in relation to the every-day problems of the artist. However, the simple charts that we present in this chapter have a different purpose than the more complicated scales of the well-known color systems, although they are similar in some respects. The latter are intended to set standards of accurate color measurement, primarily for the purpose of specification and matching, but the charts which we now suggest the reader make for himself will provide him with numerous practical pointers on color mixture in pigment form. These charts should be made as carefully as possible and kept for permanent reference.

Pigment Mixture

If you experimented with your pigments as directed in the previous chapters, you doubtless discovered that, whether you mixed them by making overlays, or by merging them on paper or canvas, or by blending them on your palette, the results indicated that pigment mixture follows certain natural laws. The following exercises are designed to reveal the best established of these, while at the same time providing simple scales for color measurement.

Primary Colors

In previous chapters we learned that various authorities choose different colors as primary, depending to a large extent on whether they are working with colored light, with pigments, or with the appearance of colored objects. Since we are dealing with pigments, we shall base our experiments entirely on the pigment primaries: red, yellow and blue, from which almost any desired hues can be mixed. These are the primaries used by many colorists, including the printer, painter and dyer. The exact hues of red, yellow and blue which will serve best as primaries may differ according to purpose. The color reproductions in this book are printed with the three inks shown in full strength (and as mixed by superimposition) in the pigment color mixture circles of Plate 1, plus black to give deeper values. As the print-

er's problems in pigment mixture are similar to those of the artist, these hues could be selected for your primaries. In Plate 9, the primaries used were Cadmium Lemon, Alizarin Crimson, and Permanent Blue. The main thing is to utilize the reddest red, the yellowest yellow and the bluest blue that your palette affords.

You should find, by the way, that your own experiments with pure pigments are brighter and truer than the color reproductions in this or any other book. Excellent though modern processes of reproduction and printing are, they rarely achieve more than an acceptable approximation of the original color.

Exercise 43: Mixing the Secondaries — When you have selected your primaries, the next move is to mix secondaries from them. (See Plate 9.) By varying the proportions of your primary red and primary yellow, you can obtain a full range of oranges. Choose for your secondary the one which seems to stand midway between your red and yellow.

Now mix primary yellow and primary blue in varying proportions to obtain a wide range of greens and select the one that seems least inclined toward blue or yellow for your secondary.

Repeat the exercise with primary red and primary blue and choose the midway violet as secondary.

Some authorities say, in substance, that by mixing equal parts of primary yellow and primary blue, secondary green is obtained. This is not quite true. For yellow, even though it is extremely intense, is light in value while blue is dark but less intense. In equal mixture, therefore, one may outweigh the other, and the result may not seem a normal green. Vary your proportions as necessary, but try to get a normal green, a normal orange and a normal violet. These three secondaries, together with the three primaries, give us our six leading colors.

Exercise 44: Mixing the Intermediaries — Now, progressing a step further, mix the six intermediaries: red-orange, yellow-green, blue-violet, yellow-orange, blue-green and red-violet. (In compounding these names, as " red " with " orange " to make " red-orange, " that of the primary is usually placed first, indicating an excess of red over the other component primary, yellow.)

As you can see, these intermediaries are mixtures of the three primaries and three secondaries. However, if you try to carry the exercise further, mixing red with green, orange with blue, or yellow with violet, you will produce not intermediary hues but grayish tones. The reason for this will be made clear when we consider complementary colors.

Exercise 45: Making a Color Wheel — The color wheel or " chromatic circle " is an extremely valuable device for establishing certain color relationships. You should make one of your own and save it for future reference. Plate 10 is offered for your guidance.

Though there is no arbitrary rule as to number of colors, a 12-hue wheel is convenient as it exactly accommodates the three primaries, three secondaries and six intermediaries. Follow the steps shown in the top row of Plate 10 (your own colors will be brighter) and you will have a completed wheel similar to the 12-hue wheel at bottom left. A convenient size is about 6 inches in diameter.

In a sense, such a wheel is a simple scale for measuring hues. Although far from accurate by scientific standards, it is most useful for the artist. The approximate " measurement " of any hue can be quickly judged by the eye if it is referred to the hues of the wheel for comparison. Of course, the more hues a wheel bears, the closer this judgment will be. Hence, some artists prefer a wheel with 18 or more hues (see bottom right, Plate 10).

This simply means providing room for a wider range of intermediate hues; the primaries and secondaries remain the same.

You will have noticed that the color wheel has something of the appearance of the solar spectrum, bent round to meet end to end. Actually, however, the two ends of the spectrum have little in common. It will be recalled from Chapter I that red, which terminates one end, has waves which are long and slow in vibration, while the waves of violet, terminating the opposite end, are short and rapid. When we try to force these ends together, as in the color wheel (we have to add purple to fill the gap), the result is highly artificial. Nevertheless, a well-prepared color wheel can prove extremely useful, as we shall see.

Complementary Colors

Chapter I showed us that when an object, such as a red book, is exposed to light, it reflects to the eye rays of light which are capable of exciting the sensation of red, and absorbs all other rays. The color is produced, or made visible, through this power which objects have (commonly known as selective absorption) of separating or subtracting some colors from light as a whole. The color of the absorbed light is said to be complementary to the remaining light, for the absorbed (colored) light plus the residual (colored) light would produce, in mixture, white light. As this absorbed or complementary light is, in the case of an object, invisible, it cannot be studied, but the scientist has learned not only how to decompose white light into its component parts (as we have seen), but how to present to view the complement of each spectral hue. If we take the three primary colors (remember we are dealing with light just now, rather than pigments), he can show us that red (Scarlet Vermilion) has for its complement blue-green (Cyan Blue); green has purple (Magenta); blue-violet has yellow (slightly orange). He can demonstrate, too,

the fact already mentioned that if these spectral primaries are mixed in proper proportions, white light results. It is also true that if each of these primaries is mixed with its complement, white light will result. In fact, any spectral color and its true complement produce, in mixture, white light.

(It is interesting to note that the so-called additive primaries of light — red, green, and blue-violet — have as their complementaries blue-green [cyan], magenta, and yellow, which approximate the subtractive pigment primaries, blue, red, and yellow.)

This repetition of truths concerning pure light would be irrelevant here were it not for the fact that from them certain valuable parallels can be drawn. If we mix together our pigment primaries, for example, we get gray rather than the white produced by spectral mixture. This difference is mainly due to the dullness of pigments in relation to light. Note that we have used a neutral gray in filling the centers of the color wheels in Plate 10.

In dealing with pigments, we can find complements much as with light. Here is one method. By mixing primary red with primary blue, we obtain a secondary, violet. This is the complement of the third primary, yellow, and vice versa. In other words, *the secondary obtained by mixing any two primaries is the complement of the third primary.*

Now we have already seen that when we mix a primary (red, for instance) with certain secondaries (in this case, orange or violet), the result is a bright intermediate hue. By looking at the color wheel, you can see that orange and violet are related to red, that is, they are near it on the wheel. If, however, we mix primary red with the secondary directly opposite it on the color wheel — its complement, in other words — we obtain, not an intense intermediate hue, but an approximation of neutral gray. This relates to what we have just learned about the three pigment primaries in mixture producing gray. The secondary green is a mixture of the two primaries, blue and yellow, so its mixture with red produces the same result as a blend of the three primaries.

As we just noted, green is directly opposite red on the color wheel. In fact, *any hues exactly opposite each other on a well-prepared color wheel are complementary.*

We cannot over-emphasize the importance of these complementary hues in work with pigments. You should memorize the principal pairs. The 12-hue wheel gives us red and green, yellow and violet, blue and orange, yellow-orange and blue-violet yellow-green and red-violet, red-orange and blue-green.

Exercise 46: Testing Complements — You will find it extremely practical to experiment with your own pigments to see which hues prove the most complementary. By comparing grays, it is easy to judge in what respects particular pigments fail. Usually, if

the grays are too warm (brownish), the cooler colors (blues, etc.) are not strong enough, and vice versa. However, you will probably find that grays produced by complementary mixtures often do lean a bit towards brown.

Uses of Complements

A strange paradox of color relationships is that *when a color and its complement are mixed together, each tends to dull or neutralize the other, but when placed side by side, each emphasizes or accentuates the other.* Thus complements have power both to destroy and to reinforce, according to the way they are employed.

Let us examine this destructive characteristic and see what use it is. Suppose you have mixed an orange that is too bright for your purpose. Thinning it with water or medium, or adding white, will make it lighter, not duller. How can you modify its intensity? By adding gray? Yes. But the use of gray often proves a deadening influence. Instead, add complementary blue. In the same way, if you have painted a green hillside and it seems too vivid, you can superpose it with a pale wash or glaze of red or red-violet.

As an example of the reinforcing characteristic of complements, suppose an artist is painting a building in bright sunshine. In order to make his sunny yellows and oranges all the more telling, he will oppose them with blue or violet shadows, which, through contrast, will enhance the

Plate 11. (See page 43.) The top chart shows typical value scales. The value of any hue can be measured against the gray scale in the center. In the bottom chart are examples of normal colors, tints, and shades. The normal colors were diluted with water to form the tints, and darkened with gray to form the shades.

brilliance of the warm tones. In a landscape consisting mainly of greens, a dash of red is frequently added to intensify the whole. Corot's paintings often exemplify this point.

Nature makes use of complements or near complements. We see stretches of yellow sand contrasting with blue of sea and sky, and purple clouds against the golden sunset. Artists have long recognized the value of such contrasts and base many of their schemes upon them.

Scales of Intensity

Let us now perform several exercises which will acquaint us with the behavior of complementary colors when they are mixed together.

Exercise 47: Color Graded to Complement — Do a watercolor wash grading by almost imperceptible degrees from red to green. (See Frontispiece.) When complements are wedded in this manner, they produce, no matter how intense, a variety of more or less neutral hues. About half way between red and green, a neutral zone will be noted in which the two opposing colors are so proportioned as to appear gray. This gray corresponds to the neutral centers of the color wheels you have made. Between the neutral zone and red will be many gray-reds, while, similarly, there will be gray-greens separating it from green. Thus, one learns that by mixing a given color with its complement in varying quantities, it is possible to produce a wide variety of intensities of both colors, along with neutral gray. Perform this same exercise with other pairs of complements.

Exercise 48: A Stepped Scale — Because of the inability of the eye to measure readily such gradual changes of intensity as shown in a graded wash of the sort described above, a stepped scale may be of more value. (See Frontispiece.) This can be done in either oil or watercolor.

Draw five small rectangles in a vertical row and fill the top one with any hue at full intensity. (Red-orange would be a good choice.) Now mix red-orange with its complement, blue-green, until it is reduced to neutral gray; fill the lowest rectangle with this tone. (This area corresponds to the neutral zone in the middle of the graded wash or in the center of the color wheel.) Now, by mixing approximately half as much blue-green with the red-orange, the tone for the middle rectangle will be procured, relatively greater and lesser proportions of blue-green being used for the areas in quarter and three-quarter intensity. (Your eye will have to be the judge.)

Exercise 49: The Color Wheel as a Scale of Intensity — A color wheel can also be made showing a scale of intensity. (See Frontispiece.) Divide the outer portions in twelve parts as in the previous wheels mentioned. Fill these with colors of full intensity. Provide a second ring within for the same colors at half intensity, and a central neutral zone.

Study, in particular, the colors at half intensity, for it is true, although strange, that most of us cannot recognize even the common colors seen in lowered intensity — gray-yellow, for instance. Not only will the preparation of this scale help you to gain acquaintance with such hues, but whenever you must mix them, the scale will show their constituents.

To make this wheel of still greater value, add an extra pair of rings between the others, the first for three-quarter and the second for one-quarter intensity.

The Effects of Juxtapositional Mixture

We all know that pigments can be mixed or blended in many ways, but there is one method which, while not uncommon, receives less attention than it should. It consists of placing in close proximity many small brush marks of two or more colors which, when viewed from the proper distance, are merged by the eye into a single hue. This method, known as pointillism, produces effects that are quite different from those resulting from the more usual methods of combining colors. We have already spoken of the strange paradox that while complements in mixture tend to annihilate each other, juxtaposed, each strengthens the other. This statement needs some modification, as the following exercises prove. (See Plate 15.)

Exercise 50: Area Experimentation — Mix together vivid red and complementary green pigments to obtain neutral gray. This proves that complements annihilate each other in mixture. Next, lay areas of the same vivid red and green, each at least an inch square, side by side. Each of these colors will now appear more intense than if seen by itself, showing that juxtaposed complements do indeed strengthen each other.

But now comes a vital difference. Cover an area about 1½-inch square with alternate stripes, each approximately ⅛-inch wide, of the bright red and green just used. You will discover as you work that, with adjacent bands of this width, marked intensification of the colors will be evident unless they are held too far from the eye. The effect may even seem dazzling, the red tending to advance and the green, especially if bluish, to retreat. A sort of oscillation is set up, making such an area more striking than the single pair of contrasting complements.

Next, fill a space not less than an inch square with a stippling of small dots of the same red and green; another with fine alternating pen lines of the same colors. Set them a few feet away. What has happened? Does the dotting and lining now prove that if complements are adjacently placed each reinforces the other, as we have stated? On the contrary, the red and green seem to merge to give much the effect of neutral gray — a tone peculiarly

vibrant, to be sure, yet almost as gray as though the two hues were actually stirred together.

What does this prove? It proves that *area has much to do with color appearances.* This is one of the reasons, for instance, why a large painting, perfectly copied or reproduced at small scale, may look disappointingly dull. The eye has a tendency to merge small varicolored areas into solid tones. For this reason, more decided color schemes are usually needed for small paintings than for large, if brilliant effects are sought.

Exercise 51: Spatter — As further proof of the importance of area, spatter a sheet of paper a foot or so square with fair-sized drops of two or three pairs of complementary colors. If the spattering is sufficiently coarse, the effect, when viewed close at hand, should prove quite brilliant (some small spots may be dull, due to uncontrollable superposition). Now, place the paper across the room. The colors should merge into an oscillating or scintillating neutrality, as did the stippling and lining of the previous experiment. This proves again that, if brilliancy in painting is sought, one should avoid the juxtapositional use, in small areas, of even the brightest complementary hues.

We stress complementary hues, for related or analogous hues (those which are near each other on the color wheel) actually seem brighter and more vital when thus employed, as you can see by performing these same exercises with various pairs of related hues. When colors are juxtaposed in larger areas, whether complementary or analogous, brightness is obtained, as we have seen.

Incidentally, it is interesting to note that when red and green are mixed by the juxtapositional method, the resultant gray usually tends slightly towards yellow, which is, as we have seen, the result of the spectral mixture of red and green.

Values

It will be recalled that value is the quality of color which has to do with the amount of light or dark which the color contains. In order to study this quality, we will now make a group of scales for measuring values.

By mixing black or white (or water or thinning medium) with a color, we can change its value without changing its hue. The easiest approach to value study, therefore, is through black and white. In black we have the lowest of all values; black stands for the absence of light. In white we have the highest value which our paper and pigments permit, white representing the maximum presence of light. This gives us two predetermined extremes. By mixing black with white in varying proportions, we can obtain innumerable intermediate values. For study purposes, it is customary to establish a limited number of progressive steps or intervals.

Exercise 52: A Value Scale — An

eight or nine-stage scale will give a good range of values for comparison. (See Plate 11.) Draw nine small rectangles in a vertical row and fill the top with your purest white, the bottom with your blackest black. Then mix the two together in varying proportions to fill the boxes between. Your eye will have to be the judge of just how much white or black is needed for each step. You will find, for instance, as have many color experts before you, that you cannot get middle gray by a half-and-half mixture of black and white. For the scientific, there is the well-known Weber-Fechner law which expresses the relationship between the strength of a stimulus (in this case, black and white content) and the intensity of the sensation (here, the value of gray). As the stimulus strength is increased geometrically, the intensity of the sensation increases arithmetically. For most artists, however, the eye is a thoroughly satisfactory gauge. Just add more white or more black until the scale appears to grade regularly from white to black.

Exercise 53: Value Scales in Color — In the previous exercise, we made a neutral scale which is used mainly for measuring whites, grays and blacks. However, a color of any hue can pass through similar intervals, as we have seen in Exercises 32, 33, and 34. In Plate 11 compare the value scales in color with the gray scale.

As you compare the light and dark values of the various hues, you will note again a fact that we have pre-viously pointed out: normal colors vary greatly in value. Normal yellow is extremely light, for instance, and normal violet is dark. It is obvious, then, that we can produce no great number of tints of yellow or shades of violet showing marked differences in value.

With such scales completed, try to register impressions of these tones in your mind. Do this, too, with all your color scales, for when it comes to actual painting you will need the widest possible acquaintance with hues, values and intensities. What we have already said about variations in the values of normal hues is, however, enough to show the difficulty of accurately measuring or classifying hues according to value, particularly by eye.

Obviously, all three of these color qualities are so closely related that it is not easy to think of them separately. If one changes the value of a color, for example, he often changes both its intensity and hue at the same time, and vice versa. Thousands upon thousands of hues, values and intensities are possible, and the appearance of all of these is further affected by area, arrangement and textures, so it is obvious that no scale or system of measurement can be of more than limited worth. However, some of the simple scales which we have just discussed, particularly the color wheel, can easily prove of considerable profit, as we shall learn in discussing color harmony and color schemes.

Color Illusions — Visual Phenomena

Colors do not always seem to be what they are. The artist mixes a hue in pigment form until it looks right on his palette or trial paper, only to find that, when applied to his painting, the effect is different. It appears duller or brighter, or even of a different hue. Perhaps it stands out too plainly, or fades disappointingly into the background. Let us investigate some of the reasons for all this.

Eye Fatigue: Afterimages

We know that if we glance at a brilliant illuminant, such as the sun, it excites our eyes to a marked degree. Not only are they dazed, but they develop a form of fatigue which causes us to see images of the illuminant, even if we close our eyes or look in the opposite direction. This excitation does not immediately pass away; the images endure for some time. We call them afterimages.

Afterimages are of different kinds, or, more properly speaking, each image passes through various stages of decay before finally disappearing. If we glance momentarily at a bright incandescent light and then turn from it, or close our eyes, we can see a definite image of the light bulb. At first it seems bright; this is called a " positive " afterimage. Gradually, it changes until it looks dark, yet is still plainly visible; this is known as a negative afterimage. By opening and closing the eyes one can often change such an image from positive to negative and back at will, as long as the retinal excitation remains sufficiently strong.

It is not so commonly recognized that afterimages can be excited by comparatively mild stimuli, yet this is true. Even areas of black or white or colored pigments can cause distinct (though somewhat pale and short-lived) images; these are the kind which principally affect the work of the artist. As a rule, however, mild stimulation excites only negative

images, so we shall confine our investigation to them.

Exercise 54: Black and White After-images — Gaze fixedly (from a point a foot or so away) at the center of a well-lighted white disk of paper an inch or two in size, placed against a black paper background, as suggested by A, Figure 16. The bigger the background the better. After a half-minute, remove the disk (without shifting the eye) and you will soon see in its place its negative after-image, darker in effect than the black background. This may take a half-second to form. For a few seconds it will gain in strength, then fade away.

When you have tried this a few times, place a black disk on a field of white, as indicated at B, and fix the eye upon it for a half-minute or so. Then remove the disk. A light spot of the same size and shape will soon appear, looking whiter than the white ground; it will grow more pronounced and then fade into nothing.

Experiment with white and black disks against backgrounds of neutral gray; the afterimages will still be definite. Place your white and black disks side by side against gray; fixate them; remove them; two afterimages, one dark and one light, will be seen simultaneously.

Turning to color, our prime interest, results are even more amazing. For color experiments, you can use your paints, but it is usually more convenient to work with colored papers.

Figure 16

Packets of construction paper are usually available in assortments of vivid colors wherever school or art supplies are sold. As a matter of fact, you can just as easily cut out brightly colored areas from the illustrations and advertisements in old magazines you may have on hand, for use in the following experiments.

Exercise 55: Colored Afterimages — Working in rather bright, clear light, place an intense red disk (any other convenient shape will do) against a large white background, as suggested at A, Figure 17; gaze at it for 20 to 30 seconds, then remove it from the paper. You will observe, if you do not shift your gaze, that the white paper where the disk has been seems tinted with an afterimage of pale

Figure 17

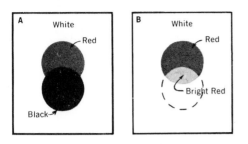

Figure 18

green or blue-green, complementary to the red. If you prefer, instead of moving the disk, you can merely shift your gaze after the period of fixation. You will find you can steer a circular spot of green at will about the paper as long as it endures.

You will perhaps note, in gazing at the red disk, a greenish fringe appearing around the edges. If you move your eyes farther from the paper, you can expand this green tone to cover a much larger area. If the eye is sufficiently fatigued, a considerable portion of the white background may seem greenish if

held at an increased distance from the eye. You may be conscious of this green long enough to transfer it to other objects in the room. Everything on which your gaze centers will, for a moment, be slightly modified by this hue, whether you realize it or not.

Now turn up a portion of your red disk so a shadow is cast, as suggested at B, Figure 17, and gaze at the disc until the afterimage border just mentioned appears; as this border spreads to cover the shadow it will tinge it with green.

We often see this phenomenon (with variations) in viewing natural objects, although we are not usually aware of it. If we look at a red vase, for instance, its shadow and background may seem dyed with just a suggestion of complementary green, particularly if the eye is shifted a bit. This is something to keep in mind in painting still-life subjects.

Now look at the red disk once more, studying the hue of the red itself. It will soon look less vivid than at first, seeming to grow duller right before your eyes. You can demonstrate this better if you overlap the red disk with one of black, as at A, Figure 18, and gaze at the center for a half-minute. Then, when you remove the black disk, you will discover, where it overlapped the red disk, a red area which for a few seconds will seem more intense than the one above. See B, Figure 18.

Another demonstration of interest is suggested by Figure 19. Place a

Figure 19

strip of red paper vertically against a white background, as at A. Fixate the center of this, and then shift it to the horizontal position B, continuing to look at the center of the red strip. An afterimage band of complementary green will be seen occupying the original position of the strip and, where this image crosses the strip itself to form a square, the red will appear less vivid than on the rest of the strip. The elusive phantom green will seem actually mixed with the red, neutralizing it.

Now for another interesting point. We have just seen that if we gaze fixedly at a color, it seems to grow slightly dull as its afterimage forms and blends with it. Contrarily, if we fatigue the eye with a color — orange, for instance, and then suddenly turn to look at its complement, blue — this complement will appear all the brighter for a moment, for, to the blue itself, the after image blue is added. This is further proof that when the eye wanders over a painting (or from one painting to another) the appearance of the colors depends somewhat on these afterimages which are constantly being produced by retinal fatigue (unless our glance is very hasty).

Cause of Afterimages

The cause of these phenomena is not difficult to understand. We recall from Chapter I that an object which appears white does so because it has the ability to reflect a considerable portion of all the light rays which it receives, so balanced as to give the effect of absence of color. When portions of the retina are momentarily fatigued through the excitation set up by a distinct color, as in these recent experiments, this balance is disturbed; the tired retinal areas are temporarily incapable of receiving the sensation of white. Being in a sense blinded to the rays of one particular color, they see only the sum total of the rays of the remaining colors of which white light is composed; these form the afterimage, which obviously must be complementary to the color itself.

If we focus on a red disk, for instance, portions of the retina become fatigued by the red, and so, to a slight extent, blind to it. Sympathetically, the retina is also temporarily blind, but to a less degree, to the closely associated orange and violet. Consequently, when we remove the red disk, portions of the eye are able to see only the other colors which make up the white light — green, blue and yellow — and these merge to form the greenish afterimage. In a few seconds, the eye recovers its sensitiveness to red and its associated colors, and the afterimage disappears.

Now perform experiments, such as you have carried out with red, using other colors. You will discover that it is possible to create a complementary afterimage for any hue. This fact is sometimes utilized in preparing color wheels. Although

afterimages are somewhat pale, they are strong enough to make hue matching possible in tints and each pigment tint can then be brought to the needed intensity.

Experiment also with backgrounds other than white — particularly with black and neutral gray. You will learn that distinct images can be formed regardless of background.

Exercise 56: Adjacent, Combined Images — The retina can be fatigued by more than one color at a time. Arrange disks of the primaries — red, yellow and blue — to form a triangle against a white background, as at A, Figure 20. Then fixate these, focusing the eye at a point at the center between the three circles. You will soon find that each color becomes rimmed with a tint of its complementary hue. If you remove the disks without shifting your gaze, pale secondaries — green, violet and orange — will show in disk form as afterimages, as suggested at B.

Such compound afterimages affect our vision constantly. When one views a painting, for example, he often fixes his gaze on one color after another or several colors at a time, although scarcely conscious that he does so. Then, as his gaze shifts, he transfers afterimages here and there. Obviously, in a painting they are seldom seen against white.

Exercise 57: Overlapping Combined Images — Perform a series of tests of the sort indicated in Figure 21, where a red disk is placed to overlap yellow, blue, black and white surfaces. After the necessary period of fixation, remove the disk and compare the various portions of the afterimage. Such an experiment should be enough to prove that afterimages do affect almost all color appearances.

One thing which we learn from all such experiments is that complementarism is natural; that colors such as we paint opposite each other on the color wheel, though wholly unlike in appearance, are still related, and so can be advantageously employed together under many conditions, some of which will be discussed subsequently.

Other Phenomena

These remarks on retinal fatigue and its resultant afterimages cover all that the average artist needs to know about this subject, for afterimages, although affecting color appearances and convincing us of the relationship between colors and their complements, are such fleeting and uncontrollable things that comparatively little practical application can

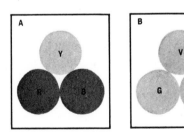

Figure 20

be made of them. Therefore, although we shall touch on them from time to time, we turn now to other phenomena of more direct application.

M. E. Chevreul, for many years the superintendent of the dyeing department of the Gobelin tapestry manufactories, included the results of his experiments with dyes in his book, *The Principles of Harmony and Contrast of Colors.* In the light of later knowledge, we know that he was wrong in some of his claims. His volume has, nevertheless, formed the background for much of the discussion of color in pigment form which has followed.

Working under the handicap of the weaver, who cannot easily make changes in his work, Chevreul discovered many strange things about color. He learned, for instance, that a thread of a given color might appear faded, if used in one place, yet intense in another. He learned that colors which are harmonious in some relationships are discordant in others. He learned, in short, the general truth we stated in the beginning of this chapter — that colors do not always seem to be what they are. Further, he worked out various rules or principles designed to assist the colorist in the practical employment of color. He particularly pointed to certain facts regarding what he called " simultaneous contrast " in colors.

We are all familiar with optical illusions of line, as when parallel straight lines appear divergent or

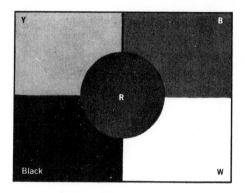

Figure 21

crooked, or lines which are short are made to look longer (see Figure 22). It is not so commonly realized, however, that solid areas of white, gray or black trick us as do lines. In other words, we have illusions of tone.

A simple illusion which we draw from physics is known as irradiation. If a bright object is seen against a dark background, it tends to look bigger than it is. If the end of an iron bar is gradually heated, for example, it seems to increase in size (beyond its actual expansion) as its temperature is raised until, when white hot, it appears to be considerably larger than the rest of the bar.

In drawing we can obtain something of this illusion. If we compare A and B, Figure 16, under bright illumination, the white circle of A will probably seem slightly more expansive than the black circle of B. The two are actually equal.

This brings us to Chevreul's fun-

Figure 22. Optical Illusions

darker because of the adjacent white. So great is the contrast, in fact, that the white circle actually looks whiter than the rest of the page.

While we have this point before us, let us turn to Figure 23. Here the tone surrounding the white area has been softened towards the outer edges to blend gradually into the page. This causes the eye to be drawn all the more sharply to the difference between the inner circle and its surrounding black; the white circle seems whiter than white — an illusion, of course.

Another interesting illusion is shown in Figure 24, where the gray looks darker against the white than against the black, although it is the same throughout. In monochromatic drawings such illusion often develop and require adjustment. We illustrate the same point again at A and B, Figure 25; the two gray squares are exactly alike in value, whatever the eye may say. At C we show a somewhat different application of the same principle, for here each of the juxtaposed tones, though actually flat, appears through induction (if rightly viewed) to be a bit graded. Each tone seems slightly lighter or darker toward the edge than it is, through simultaneous comparison with the adjacent tone.

Exercise 58: Simultaneous Contrast, Black and White — If you perform the experiments just discussed, you will find them more convincing than the illustrations shown here. It should be clear when you have fin-

damental Law of Simultaneous Contrast, which tells us, in substance, that if we arrange colors — this includes white, gray and black — side by side or in such manner that one is seen against a larger area of another, they tend to modify one another. In other words, colors are modified in appearance by their proximity to other colors.

In A, for instance, the circle looks brighter because of the black against which it is placed, and the square

ished that even simple tones of black,
white and gray are not always what
they appear to be.

Colors likewise can deceive the eye.
If we should tint the white circle
at A, Figure 16, with color — yellow,
for instance — the tint would look
brighter as seen against the black
than if viewed by itself on white paper.
This illustrates one of Chevreul's
rules that all light colors seem most
striking against black. And, refer-
ring again to B, Figure 16, it is not
hard to understand that all dark colors
seem most striking against white,
for this small black circle could easily
be supplemented by any dark hue
with little change in general effect.

*Exercise 59: Simultaneous Contrast
of Colors* — Now carry out the exper-
iment suggested by A and B, Fig-
ure 25, using small colored squares
instead of gray ones. If you substi-
tute green for the gray, for instance,
it will appear darker on white than on
black. Further, if you substitute light
and dark colors for the large white
and black squares, you will find that
dark colors upon light colors look
darker than on dark colors, and,
conversely, light colors upon dark
colors look lighter than on light
colors. Thus, so far as values are
concerned, colors appear to be quite
other than what we know them to be.

It is not only values which depend
on environment, however. Place a
small square of neutral gray on a
blue background, and the gray will
seem to take on an orange cast. The
same gray against orange will show

Figure 23. Simultaneous Contrast

Figure 24

Figure 25

a hint of blue. This will be very evident if large squares of blue and orange are placed side by side, each centered with a small square of the same gray, and with tracing paper laid over the whole.

As a striking test, lay small green circles in the centers of two adjacent large squares, one light yellow and the other dark blue, as in Figure 26. The green against the yellow will seem darker in value than against the blue, and slightly blue-green in

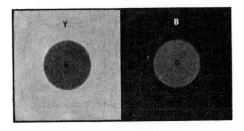

Figure 26

hue. The green against the blue will seem slightly yellowish. Not only will the two small green areas apparently differ, but the yellow, contrasted with the green and blue, may appear a bit orange, and the blue, contrasted with the yellow and green, a bit purple. Tracing paper placed over the colors will emphasize the contrast.

This test demonstrates Chevreul's argument that colors are influenced in hue by adjacent colors, each tinting its neighbor with its own comple-

ment. Intensities, as well as values and hues, are affected by environment, as we have already seen. If two complementary colors lie side by side, each seems more intense than by itself.

Experiments with colored paper will make clear these and other interesting facts about the effects of colors on each other when they are seen in close proximity. You will learn, for instance, that dark hues on a dark ground which is not complementary will appear weaker than on one which is; that light colors on a light ground which is not complementary will seem weaker than on a complementary ground; that a bright color against a dull color of the same hue will further deaden the dull color; that when a bright color is used against a dull color, the contrast will be strongest when the latter is complementary; that light colors on light grounds (not complementary) can be greatly strengthened if bounded by narrow bands of black or complementary colors; and that dark colors on dark grounds (not complementary) can be strengthened if similarly bounded by white or light colors.

These pointers serve merely as an introduction to this interesting subject. The reader who cares to investigate such phenomena further can find much of value in Chevreul's own book.

Remember that the laws of simultaneous contrast do not hold unless the contrasted colors are placed in close proximity.

A Summary of Chevreul's Laws

Here is a summary of the most important of Chevreul's laws of simultaneous contrast.

1. Colors are modified in appearance by their proximity to other colors.

2. All light colors seem most striking against black.

3. All dark colors seem most striking against white.

4. Dark colors upon light colors look darker than on dark colors.

5. Light colors upon dark colors look lighter than on light colors.

6. Colors are influenced in hue by adjacent colors, each tinting its neighbor with its own complement.

7. If two complementary colors lie side by side, each seems more intense than by itself.

8. Dark hues on a dark ground which is not complementary will appear weaker than on a complementary ground.

9. Light colors on a light ground which is not complementary will seem weaker than on a complementary ground.

10. A bright color against a dull color of the same hue will further deaden the dull color.

11. When a bright color is used against a dull color, the contrast will be strongest when the latter is complementary.

12. Light colors on light grounds (not complementary) can be greatly strengthened if bounded by narrow bands of black or complementary colors.

13. Dark colors on dark grounds (not complementary) can be strengthened if similarly bounded by white or light colors.

Color Activity

When you perform experiments like those just suggested, you will see that colors vary greatly in their affective and attentive powers. Some can best be described as active, lively, restless, insistent, positive, bold, expanding or advancing. Others seem passive, negative, subdued, timid, submissive, reserved, contracting or retreating. Some suggest warmth, others coolness; some impress us as heavy and inert, others as light and animated. You should cultivate the habit of sizing up different colors which you see about you, noting their characteristics and your reactions to them. This will help you, when it comes to painting, to choose those colors best fitted to your mood and purpose, a matter of great importance.

Warm and Cool Colors

Some of these various characteristics of colors seem particularly significant or are sufficiently tangible to be understood easily and put to practical use. That certain colors seem warm and others cool is a fact that can be often used to advantage. Hues of the red, orange and yellow group are the ones considered warm. They suggest flame, blood and sunshine, and are especially appropriate

when bright, stimulating effects are sought. Hues analogous to blue are thought of as cool. They bring to mind cool water and ice and the sky of winter, and are at their best (there are exceptions) for purposes requiring restraint and subordination.

Cool colors also suggest distance or expansion and are, therefore, often called " retreating " colors; warm colors, contrarily, are classed as " advancing. " If we wish to paint distance or make areas seem spacious, we give preference to cool colors; in the foreground, or where we wish attention concentrated, we use warmer tones. As warm colors generally are associated with light, so cool colors suggest shadow, another fact that we apply when painting.

Of the various advancing colors, red and orange are considered to have the greatest force. Advertisers use them as a means of gaining maximum attention. The artist employs them when he wishes particularly to emphasize a portion of his subject. Yellow has less power. It carries well and has compelling force against dark or complementary backgrounds, or if bordered or accented with darker areas, but is relatively weak if contrasted with light tints or white.

Retreating colors, although carrying well as dark spots, often show weakness of hue if viewed from a distance. Greens and violets stand at the half-way point between heat and cold. They contain both warm and cool colors and vary proportion-

ally in their abilities to advance or recede. Yellow-greens and violets leaning strongly toward red tend to advance and have considerable power to attract; blue-greens and blue-violets tend to recede and have little compelling force.

The carrying or attractive power of colors depends, as our experiments have indicated, not alone on hue, but also on value and intensity. A gray-red, for example, although it may attract as a dark spot, will have little force compared with the same hue unneutralized. This will be plainly evident if paper slips of these colors are placed across the room.

We have already seen that the activity of colors depends to no small extent on background. Distance, too, plays an important part in color strength. If one looks down a long city street with brick buildings on either hand, he will generally observe that the reds of the brickwork appear duller and less distinct the farther away they are, particularly if the atmosphere is a bit hazy, a blue or purplish hue gradually taking the place, in the extreme distance, of the red. In other words, warm tones usually appear cooler in proportion to their distance from the eye. This is true of all colors to some extent.

Cool colors do not always seem to retreat, by the way; certain vivid hues, viewed near-by, appear particularly vigorous and emphatic, especially if against a complementary background. The author once noticed a bright blue automobile near at hand. Con-

trasted with brown and red buildings, it seemed extremely conspicuous, but as it drove away its color softened rapidly. Such popular, if unscientific, color descriptions as " hot turquoise, " " electric blue, " " shock green, " etc. are further evidence that in certain values and intensities even blues and greens might seem warm rather than cool, advancing rather than retreating.

Not only do colors show such activity as we have just mentioned, but they have the power also of stimulating a wide variety of emotional reactions — as many of us are aware. Red and orange are exciting; blue and green tend to have a calming effect. These are generalizations that most people accept without thinking. Then there are the traditional associations of certain colors with particular kinds of human qualities or emotions: passion is associated with red; jealousy with green; purity with white or sometimes blue; evil with black or red. But the emotional interpretations of color are far from universal. Yellow, which is an accepted synonym for cowardice in the western world, for instance, is said to be a holy color in the Orient where it is worn by Buddhist monks.

Color also seems to have very personal meanings. We are all conscious, to some extent at least, of individual color preferences. Color consultants to industry, who have done a great deal of research on this subject, tell us that blue, which is usually listed as the most generally preferred hue, is often the choice of the individual who is rather quiet, reserved, retiring, and doesn't care to appear conspicuous. Red, on the other hand, and understandably, is more likely to be the choice of the outgoing personality who loves excitement and enjoys being the center of attention. Some authorities have gone much further in their attempt to see complicated psychological meanings in color preferences, but, thus far at least, their interpretations are largely speculative and of little concern to the artist, so we shall not discuss them in detail here.

What we have tried to offer here is enough to show what a complex thing color is, emphasizing the need for serious study and experimentation on the part of the earnest student. Yet one can paint successfully (and many artists do) with little knowledge of the reasons behind such things as we have been discussing.

Color Harmony

Experience has taught us that certain combinations of colors, whether in nature or art, affect the eye and mind agreeably, while others give offense. We call the former " harmonies, " the latter " discords. "

Just as numerous attempts have been made to discover the laws of light and of color vision, and to invent practical systems of color measurement and notation, great effort has been expended in trying to ferret out the reasons why some combinations of color are pleasing and others are not, and to devise laws to insure harmonious color employment. We have finally learned, however, that even if it were possible to grasp all such reasons, workable laws guaranteeing immunity against chromatic discord still could not be devised.

In view of the contrary claims of some writers, we offer the following arguments to substantiate our statement.

First, as we have demonstrated, colors change in effect according to their environment, each hue being modified by those adjacent to it. Color harmony is not merely a matter of selection, therefore, but also of arrangement — a fact not nearly as commonly recognized as it should be. A color scheme extremely pleasing to the average person can become, in rearrangement, positively disturbing. Arrangement obviously cannot be controlled wholly by rule — at least in representational paintings.

Area, like arrangement, influences color appearances, as we have seen. Harmonious schemes can often be

made discordant, or at least uninteresting, simply by increasing or decreasing certain color areas. Of course, the reverse is also true. It is easy to see that a small spot of vivid red, which delightfully reinforces, through contrast, a large area of bright green, might, if sufficiently expanded, rival the green, causing a disturbing division of interest. But there are no arbitrary rules to be followed with regard to area and color harmony.

Nor are there definite laws governing the use of such phenomena as the oscillation that we observed in Exercise 50 when alternating bands of complementary colors were viewed from a certain distance. Yet effects such as this are capable of making some schemes disagreeable and others pleasing or telling.

Texture, although not a quality of color, is another influence that can seldom be ignored. In architecture and decoration, for example, materials harmonious in color often show textural inconsistency or discord. A mere coating of varnish, changing dull woodwork to shiny, can be enough to upset a scheme completely. Even in painting pictures, textural harmony is almost as important as color harmony — the two are closely wedded — yet there are no clearcut laws.

Color fitness or suitablility must also be considered, as must that ever-present matter of personal taste. After all, who is to say which colors harmonize and which do not? We have all seen that changing fashions can have a considerable effect on the average person's ideas of what colors are or are not attractive and suitable for particular purposes, especially in relation to women's clothing and interior decoration. There are also, as we are all aware, attitudes toward particular colors and color combinations that stem from temperament, national traditions, climate, environment and other unpredictable factors.

This should be enough to warn the student against the exaggerated statements of writers who claim or imply that their methods or systems of obtaining color harmony are infallible or universally applicable. Printed laws and clever devices designed to reveal color schemes can certainly be of help, but only in a very limited way.

Referring to laws of harmony, Matthew Luckiesh, in his book *Color and Its Applications* summed up the situation this way: " These ... are meant to be mere guideposts and are not to be taken as distinct boundaries of the different classes of color harmonies. In fact, a given harmonious arrangement may not be in accordance with any single principle, but is likely to involve more than one. No simple laws of color harmony can be framed which will be separated by distinct boundary lines. Furthermore, when other factors are considered, such as the indefiniteness of individual taste, and the meagerness of data, it must be concluded that

these laws of color harmony can be viewed at present only as general statements. They will not become more specific until the accumulation of knowledge has made this simplification possible and doubtless will never be expressible with exactitude. It is not intended that the foregoing statements should discourage the use of these general laws, or the establishment of others as the knowledge of color harmony accumulates, but they should serve to caution those who take these laws too seriously."

General Laws of Color Harmony

From Chevreul on, so many writers have discussed these laws that we shall not attempt to go into them thoroughly here. The reader who is interested in the theoretical aspects of color harmony will want to investigate all the books on this subject (many are listed in the Bibliography of this volume). However, the painter whose main concern is the representation of actual places and things can base his harmonies largely on nature, his problem being less difficult than that of the designer or others who use color in more individual ways.

So we shall stress actual color schemes to start the student on his way. Then, if he does some further reading about color, keeps in mind what he learns of color harmony in his observation of the world around him, both in the effects of nature and in man-made objects (including paintings), and constantly practices with his pigments, he will gradually develop the aesthetic instinct which the artist needs.

**One Color
with White, Gray or Black**

The simplest scheme we find (if of sufficient importance to dignify with the name) is that of an individual hue, used in one value and intensity, in conjunction with white, gray or black (taken individually or collectively) and sometimes with the addition of silver or gold. A common illustration of this type of scheme is the booklet printed with black ink on white paper (the type masses giving the impression of gray), and with a cover of colored stock, or with initials or decorations of one tone of a single hue.

Schemes of this kind seldom give offense, for there is nothing about any single color, pleasing in itself, which should prove objectionable when used in conjunction with white, gray or black. Some schemes are more effective than others, however. As a rule, if a single color is to be used with large areas of black, a warm one — red, orange or rich yellow — seems most effective; these colors have a brilliancy and vigor which appear to relate them to black. If such cool colors as blue, blue-green or blue-violet are employed with black, they are at their best if quite intense. A pale violet on black is likely to seem uninspiring — but,

again, area, texture and personal taste might make any combination effective, or at least acceptable, in certain circumstances.

Almost any color can be used with white. Blue and white has always been a popular combination, as has red and white. In fact, it would be difficult to imagine a color that could not be combined with white, providing, of course, that the areas and textures were balanced properly.

The Monochromatic Scheme

The painter makes little use of the type of scheme just discussed, so we shall turn to the simplest one which he does employ: a single hue used in any desired number of values and intensities. Such a scheme is generally called " monochromatic " (one color).

A monochromatic scheme is merely an extension of the one color with white, gray or black to include all values and intensities of the color used. The most frequent illustration of this scheme is the drawing done on white paper with a single color — sepia, for instance — the values ordinarily varying from light tints to dark shades. Such variations of one hue are sometimes called " self-tones. " There are those who insist that in the use of self-tones there can be no color harmony because there is nothing with which the color could possibly agree or disagree. Strictly speaking, this is true. Such a scheme undeniably runs the danger of becoming monotonous, but it is surprising how colorful some such arrangements are. A sketch done in white or black or both on colored paper would also fall within this general category. Such a sketch sometimes seems surprisingly rich in hue. In a scheme of self-tones, there is usually ample interest if the values are sufficiently contrasted.

If the artist wishes to obtain slightly more variety than the strictly monochromatic scheme affords, it is a simple thing to add inconspicuous suggestions of other colors. One could, for instance, use blue as the predominant color, with perhaps just a hint of the related hues, green and violet, even adding the slightest indication of warm tones of a more-or-less complementary nature. These subtle touches, barely distinguishable, could give the impression of a satisfying opulence of hue, yet the drawing would remain fundamentally monochromatic. Any other color could be selected as the predominant hue and supported with subtle hints of analogous and complementary colors.

Analogous Schemes

Relatively speaking, all schemes classed as monochromatic are rare in the work of the painter, so let us turn to a slightly more complicated type, the analogous or related scheme. As its name implies, such a scheme is made up of colors which are near each other in the spectrum. Orange, yellow and green, for example, form

an analogous scheme because they all contain the common factor, yellow.

A glance at a color wheel will show what groups of colors are analogous. Refer to the 12-hue wheel in Plate 10. If we start with yellow, we note that yellow-orange and yellow-green, which are made up largely of yellow, are particularly close in relationship. These three form a " close " analogy. If to these we add orange and green, each of which contains some yellow, this entire five-hue group is analogous. Strictly speaking, we can even add red-orange and blue-green (though here we approach danger) because each of these has a slight yellow content. This gives us, centering about yellow, seven hues out of the 12 of our scale, or more than half the wheel, somewhat related.

In arranging analogous schemes, however, the more colors we include, the greater our difficulties; typical analogous schemes usually take in not more than a third or a quarter of the color wheel. Schemes based on two, three, four and sometimes even five hues (in relation to a 12-hue wheel) are perhaps the safest and surest of all the schemes available to the artist. In other words, there is no easier way for one to get harmonious color than to limit himself to a few hues showing a clear indication of mutual relationship. As one increases his number of analogous hues to six or seven, however, thus taking in half or more than half of his 12-hue wheel, he loses the true effect of analogy. In a seven-hue scheme such as that mentioned above centering about yellow, the hues, strictly speaking, are analogous in the sense that they are slightly related because of the common bond of yellow, this being present, although in small proportion, even in the red-orange and blue-green at the extremities. We know, however, that blue-green and red-orange are actually opposite on the chromatic circle and therefore are complementary. Thus, though such a scheme may be pleasing enough, we have stretched a point in calling it analogous when two of its colors are true complements.

This is why we urgently advise the student never to use at one time, as analogous, more than those colors occupying approximately one-third of the wheel. It is, of course, possible to have analogous schemes of six or seven or even of innumerable variations of hue, provided they show such slight differences that they could all be included within approximately one-third of the color circle.

Even if one does limit himself to this area, chromatic success, although likely to follow, still cannot be guaranteed. The author once noticed a florist's delivery truck of a pale violet hue standing before a brick wall which, in the sunshine, was a vivid red-orange. Both these colors had quite a bit of red as a common factor, but it was not enough to relate them pleasingly. The delicate violet could scarcely have seemed

more out of keeping anywhere than it did against the vigor of the red brickwork. But here, again, texture was a contributing factor, the shiny surface of the truck reflecting an unpleasant glare in the bright sunshine while the brickwork was enlivened by the interplay of light and shadow on its uneven surface. The size of the truck and its proximity to the wall may also have contributed to the discordant effect.

Analogous Schemes with Dominant Hue

Before leaving the matter of analogous schemes, we should make clear that, although they are often among the most pleasing and easy to handle, the very unification which makes them harmonious may at the same time make them monotonous. The artist must seek to develop in them sufficient hue interest (as well as variety of value, intensity and arrangement) to prevent monotony.

One of the easiest means of obtaining interest is by placing emphasis on a dominant hue. There are various ways of doing this. A particular hue can dominate because of its large area, dark value (against a lighter background), light value (against a darker background) or intensity. In analogous schemes which are light in value and low in intensity, domination of one hue is often brought about through increased area. Interior decorators frequently use such schemes for backgrounds.

Analogous Schemes with Complementary Accents

When he feels too strongly the monotony of an analogous scheme, the artist can enliven it by the introduction of complementary accents. Such accents, particularly if brilliant, generally have a power out of all proportion to their size. A single touch of color complementary to one hue — usually the dominant — of an analogous scheme can give surprising life to the whole. As pointed out earlier, Corot often added a touch of red or reddish brown — perhaps a cow or a man's cap or jacket — to give vitality to the somewhat somber greens of his landscape.

Complementary Schemes

It is but a step from this use of complementary accents to complementary schemes, sometimes known as " harmonies of contrast. " Under this heading we can include any pleasing schemes which conspicuously introduce opposite colors. In fact, the majority of all color schemes are to an extent contrasting, the contrast usually being developed by means of complements.

Our experience with afterimages and simultaneous contrast made clear that a very definite relationship exists between the colors we call complements, even though they lack the unifying influence of any common hue. Green and red, for instance, are as unlike in appearance as any

two colors could possibly be, yet we have seen that even they are related. It is doubtless because of this subtle relationship that we like to bring into opposition colors which on casual inspection seem wholly dissimilar. Perhaps, as some scientific investigators suggest, this is due to some physiological or psychological need for balanced retinal stimulation. Whatever the reason, it is certainly true that a majority of people prefer harmonies of contrast to those of analogy. (The familiar phrase " harmony of contrast " would seem inconsistent, by the way, if we did not know that opposites have this strange affinity.) Some go so far as to say that color schemes never seem to them complete and satisfying unless they contain *all* the leading colors in balanced pairs. Whatever one thinks about this, nature, as we mentioned earlier, is profuse in complementary schemes and we enjoy her variety.

We must control our contrasts, however, or we achieve instead of harmony, chaos. We would seldom think of the combination of equal areas of fully intense complementary red and green as pleasing, for instance. Nor would we enjoy a similar arrangement of brilliant yellow and intense violet. This can be summed up in the general law that one should *never base a color scheme on complementary colors in equal areas and full strength.* The most perfect exterior or interior work in the world would be ruined if alternately striped with equal bands of brilliant red and green. Such a contrast has strong attentive interest, but that is its only virtue. A suit made of equal stripes of orange and blue would compel attention, but we could scarcely call it beautiful.

If we examine this rule, however, we find the key to successful complementary arrangements. Note it advises us not to use complements " in equal areas and full strength. " Here lies the key, for we can employ complements to advantage in unequal areas or in varying strength. A large red area and a small green area, for instance, often seem harmonious, for the dominent red gives unity to the combination. Likewise a brilliant red can be employed successfully with a neutralized green, even though the areas are equal, for the red will dominate because of its superior intensity.

Another type of complementary scheme which can be very satisfying is one in which closely related tones of one color are contrasted with similarly related tones of the complementary color. Orange and near-orange, for instance, might be contrasted with similarly related blues, the orange representing all the warm tones in the subject and the blue all the cool. These could be kept from clashing by the expedient of working some of the warm tones into the cool, and vice versa. As a further harmonizing influence, both the orange and the blue could be somewhat neutralized. Both colors could

also be modified by other hues, the warm tones with traces of yellow and red, the cool areas with green and violet. In other words, such a scheme, in exact analysis, would be based on two delicately balanced analogous groups, one with orange and the other with blue dominant, the cool group probably less assertive than the warm. One advantage of a scheme of this kind is its relative simplicity. It makes it possible to achieve a rich effect with a limited palette.

Some artists feel that such a warm and cool combination affords the student the best approach to his color problems, especially as they relate to outdoor sketching. In his book, *The Art of Water Colour Painting,* E. Bernard Lintott says: " For a young student there cannot be a better way of entering upon the study of watercolour than by rigorously banishing all but two colours from his palette. It is the best and surest way to the study of full colour. The colours should be a cold one and a warm one; Cobalt Blue and Warm Sienna — or Prussian Blue and Burnt Sienna — are two combinations which lend themselves to a great variety of treatment.

" The opposition of the qualities of warm and cool colour are then only to be looked for, and a valuable lesson can be learned in this way as to the preservation and balance of all important masses of colour. The greatest watercolourist the world has ever known began in this way,

J. M. W. Turner, and it was by the absolute mastery of these simple means that he finally entered into that opulence of full colour that few but himself have ever achieved. "

The reader is heartily urged to try some such limited palette (this is a worth-while exercise for the oil painter as well as for the watercolorist) as a test of the value of this recommendation. If there is danger from thus employing colors which are complementary, it is that dullness may creep in where they merge, particularly if they are absolute complements.

Near and Split Complements

The eye does not demand that, in contrasts of complementary nature, absolute complements be used. This would be difficult, as we know, even if desirable. But, fortunately, complements which are only approximate or " near " often seem more pleasing than those which are true. The term " near complement " is self-explanatory. Violet is the true complement of yellow; blue-violet and red-violet, its near complements. If we speak of these near complements in their relation one to the other, we call them " split " complements, as they are split or separated by the true complement.

The 18-hue color wheel in Plate 10 shows a helpful device in the form of a pivoted pointer so designed that if A be directed towards a given hue, B and C indicate the near or

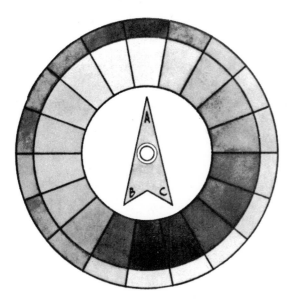

Figure 27. A device for determining split complements is shown here on an 18-hue color wheel. When A points to yellow, B and C indicate the split complements of yellow: red-violet and blue-violet. See Plate 10.

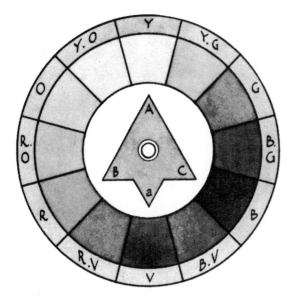

Figure 28. A 12-hue color wheel is shown here with a device for locating triads. The large triangle A-B-C can be moved (or drawn) to indicate any group of three equidistant colors. The small "a" indicates the complement of the hue at A. See Plate 10.

split complements. This wheel and pointer are shown in black and white in Figure 27.

Triads

If we base a color scheme on a color and its split complements, or on hues mixed from them, we can obtain a fairly wide range of hues, but none of them will be brighter than the color itself and the two split complements in their full intensity. Sometimes such a range proves too limited. When it does, we can use the two colors, each of which is a step further removed from the true complement. Thus, if yellow should be taken as a hue to dominate a color scheme and the split complements red-violet and blue-violet (alone or in mixture) should prove too dull to hold their own, red and blue might be substituted. In this case, we would be using three colors equally spaced on the wheel. This combination is called a "triad." A pivoted pointer for locating triads is shown with the 12-hue color wheel in Plate 10. When A points at a given hue, B and C reveal the other two component colors. This wheel and pointer are reproduced in black and white in Figure 28.

Though mixtures obtained from triads can be very rich and beautiful, triads by no means guarantee color harmony. The red-yellow-blue triad is made up of our three primaries. We know that practically all colors can be mixed from this com-

bination, discords as well as harmonies. To get effective results, therefore, one hue of the three is usually selected to dominate the scheme and the other two are mixed together or with the first, or are greatly diluted, or otherwise rendered less potent. This produces a definite scheme with a dominant hue. Some triads have less brilliancy than others, but it is best, even so, to select one of the hues to dominate.

When a color scheme is based on a triad, one of the most certain ways of preventing rivalry between the basic colors is first to select one as a dominant and then to "veil" the other with it. This veiling can be done either through superposition of

Plate 12. (See page 44.) Monochromatic minglings of black with primary, secondary, and intermediate colors are demonstrated here. The primaries mingled with black are shown at full intensity, and after scrubbing. Note the variety of tones in each of these minglings.

Plate 13. (See page 45.) Mingling many pairs of colors is an excellent way to learn the art of color mixture. The top row shows primaries mingled to produce secondaries and intermediates. In the next two rows, primaries are mingled with secondaries. The two bottom rows show the mingling of complements to produce a variety of bright and neutral tones.

washes or glazes or by admixture. If, for example, a red-yellow-blue triad were selected, red might be chosen as the dominant color. The red could then be washed over both the yellow and the blue which, to further emphasize the red, could be used in light tints rather than at full strength. In general, veiling is a good way of securing chromatic balance, simply and quickly. Another play-safe method used by many artists is to distribute each of the leading hues in a painting in such a way as to weave an all-over color pattern.

An important point to remember in building any color scheme is that a pleasing effect depends as much on a satisfying arrangement of values and intensities as on the particular combination of hues.

Exercises for Discovering Color Schemes

The following exercises, based on the minglings which we suggested you try in Exercise 28, Chapter VI, are designed to reveal quickly a wide variety of possible color schemes which will have numerous applications. Other exercises, similar in purpose, might be performed with oil paints, of course, but in these we will use watercolor pigments.

Exercise 60: Monochromatic Minglings — With Plate 12 as a guide, mingle with black, one at a time, at least the 12 normal hues of your color wheel. This experiment will open your eyes to the astonishingly varied and complicated effects you can obtain merely by mixing individual hues with black.

Wet a rectangular area (about 3 by 4 inches) in the upper left-hand corner of a sheet of watercolor paper or board approximately 15 by 22 inches in size, which must be laid flat. (You need not work to definite boundary lines which are an unnecessary handicap.) Into this puddle or very wet area, shake a few drops of intense red and black pigments and allow them to spread. Manipulate them with the brush so that in places they retain their full strength while in others they blend quite freely or are greatly diluted; part of the paper should remain white. It sometimes helps to rock the board or tip it or even to blow the pigment in the desired direction in order better to control the results.

When you have made a similar mingling for each of the normal hues on your color wheel, make a second series of minglings of the same colors, perhaps beneath the first, scrubbing these when dry to produce softer tones. Make another series substituting gray for black and using lighter values of all the colors. Next, do a second sheet, similar to the first, using other colors and perhaps a different black. Try black ink, for instance. It is capable of surprisingly brilliant effects. By surrounding bright spots of color — particularly the lighter hues such as yellow — with black ink, striking contrasts can be formed.

Many of the combinations which develop in these minglings will suggest ideas for adaptation in paintings. Some will look like clouds or sunsets; others like foliage or flame; still others like fabric or marble. The possibilities are endless.

Exercise 61: Mingled Pairs — When you have tried all the monochromatic arrangements at your disposal, perform the same experiments with minglings of two hues at a time (see Plate 13). Begin by mingling the primaries — red and yellow, yellow and blue, blue and red. Note how the minglings of each of these combinations produces a range of hues that includes, besides the two primaries, the resultant secondary and intermediaries.

Next, combine each of the primaries with its analogous secondaries: red and orange, yellow and orange, yellow and green, blue and green, blue and violet, red and violet. These will probably appear very similar to the previous minglings of the primaries.

Finally, try combinations that include complementary hues and note how such minglings create a great variety of tones, ranging from the brilliant areas of your pure colors to neutralized hues where the complementaries mix and mingle.

Exercise 62: Three-Color Minglings — Endless combinations are possible when three hues are mingled (see Plate 14). For a start, use each of your normal colors and its split complements, then all of the triads

your wheel suggests. Try scrubbing some of them after they've dried. This process brings the colors together, creating soft and sometimes extremely beautiful harmonies.

Don't do any of this work in a perfunctory way. Carry out these exercises conscientiously and try to memorize some of the best effects. Save all these sheets, too, for future reference, with the names of the component hues noted.

Exercise 63: Color Schemes — Now base color schemes on some of your minglings, as a test of their practicability in this direction. It is generally best to select for a color scheme only a few of the tones visible in any one mingling. As a means of accomplishing this, lay finders such as we have already described — strips of paper with holes through them a quarter-inch to a half-inch in size — on the mingling and shift them, experimentally, until a pleasing combination of hues is revealed, the remainder of the colored areas being hidden from view. With these finders clipped in place, you are ready to proceed with a drawing or design inspired by the scheme thus revealed.

Analyzing Color Schemes

As a means of increasing your awareness of color schemes, you would do well to study and analyze those of the masters or, in fact, any good paintings that you are able to observe. You can use reproductions in magazines or books for this pur-

pose, but of course it is far better to study the paintings at first hand since reproductions, no matter how carefully made, are often quite different from the originals. For one thing, the tremendous reduction in size that is so often necessary produces, inevitably, a distortion in the area relationships; for another, the best color printing processes cannot duplicate the exact effect of the colors and textures of paint on canvas or watercolor paper. However, poor substitutes though they may be, reproductions will certainly serve the purpose if you are not in a position to study good paintings whenever you wish to.

In analyzing the color schemes of some paintings, particularly of large canvases, you will often find it perplexing to decide just what the fundamental color scheme is. Don't let this worry you too much. As we have already indicated, generally no definite line of demarcation can be drawn between color schemes. Several kinds of schemes are often combined in a single painting. Many schemes are so complex that they could easily be classified in a number of ways.

So, in your analysis, study the infinitely varied ways in which great painters have used color, observe the effects they have achieved, and experiment with variations of them in your own painting. Gradually, you will develop your own ability to choose colors and combine them in harmonious arrangements.

Plate 14. (See page 46.) Three-color minglings suggest a wide range of color schemes. Here are minglings of adjacent hues, of near or split complements, and of triads. Try them at full intensity, scrubbed, or veiled with a single-color wash.

The Aesthetic Instinct

Lacking the guidance of definite rules and regulations for color harmony, the artist must rely to a considerable extent on what we rather loosely term the aesthetic instinct or the " eye. " This vague, subconscious power helps him in many ways. Strangely, he can often depend on it more than on his conscious judgment. Although it varies greatly in different individuals, it is present to a marked degree in most of us who feel an interest in painting (possibly it is a cause of that interest), and, even among those who seem to lack it most, it can be cultivated.

The comparatively undeveloped instinct of the novice is frequently of far more use to him than many of the rules and regulations which he consciously acquires. Although the author would be the last to belittle the valuable things which the student can be taught, he feels it would be unwise indeed to put this knowledge wholly above instinct. In selecting color schemes, for example, he should place great reliance on this power, choosing the colors which his " eye " tells him are right.

When it comes to painting, let him fearlessly apply his color; his advance will be faster and more substantial than if he weighs every move and so proceeds too conservatively. Once he has a number of colors on his paper or canvas, he will usually recognize those which are discordant or unpleasant. He may not know the why of the discordance (although it would be well for him to try to analyze it), but if he senses discord, he can change or remove the offending pigments.

Even the professional artist relies to a surprising degree on this subconscious sense, applying hue after hue more or less intuitively. If anything chromatically offensive develops, his intuition gives warning and he makes the necessary changes before going on. This bold method of working, with reliance on instinct or " the eye, " strengthens that instinct.

In fact, it seems that anything which one does to further his knowledge of color or his appreciation of it reacts in this advantageous manner.

We have spoken of the value to be derived from investigation of the laws of color science; an understanding of color can also be broadened through a study of nature. For nature, although not all perfection, as some writers would have us believe, is a never-failing source of color harmonies and so always of interest to the painter. The student should early acquire the habit of sketching from nature and of studying her ever-changing hues with the thought in mind of their interpretation in pigment form. It is a splendid practice to carry a little white cardboard with a rectangular opening in the center (perhaps an inch and a half by two inches in size), holding it upright, as a finder, peeking through it with one eye closed, selecting pleasing " pictures " much as is done with the viewfinder of a camera. By comparing visible hues with the white of the card, it is easy, after a bit of practice, to estimate what pigments would be necessary for their representation.

Works of art are also splendid illustrations of color harmony, as Walter Sargent points out in his excellent book, *The Enjoyment and Use of Color* (unfortunately now out of print but still available in many libraries). Familiarity with works of art, according to Sargent, " educates our eyes as good music does our ears, and develops our discrimination and enjoyment beyond what can be gained in any other way. Works of art show us in perfected form what we are striving to attain in our experiments with color, and thus give a new meaning to our more-or-less crude results. The combinations of color in nature are often more beautiful but are complicated with other interests, and the harmonies, although highly suggestive, are seldom set forth as clearly as in art. "

We should, in fact, look for color schemes everywhere, not only in nature and in works of art, but in everything we see that depends on color — rugs, wallpapers, upholstery fabrics and home interiors; advertisements, book jackets, magazine illustrations; window displays, stage settings and costumes; women's fashions; the possibilities are endless. It is even a good idea, especially for the student painter who is not yet sure of his own color judgment, to make notes or color sketches of attractive color schemes (no matter where he sees them) with the idea of adapting them for use in some future painting. By thus training himself to look for color schemes, he will gradually become aware of the many factors that can create discords and the subtle balance that is usually needed to make a complicated scheme harmonious. It is then just a step to creating successful schemes of his own.

If the reader, having faithfully performed the exercises set forth in this book for his guidance, now finds

himself perhaps more confused than when he began, let him not be dismayed. Such a feeling is quite normal at this point. Color is a fascinating subject, but a most confusing one, and we have barely touched on many aspects of it. The more one learns about color, the more he comes to realize how little he knows. For the scientist, there are endless unanswered questions to be investigated, but for the artist, in the long run, there is only one: How can he use color to create a work of art? No theory of color vision or color measurement or color harmony can give him the answer to that question. Only his own talent, strengthened and developed by training and experience, can help him perhaps to find it someday. It is our hope and belief that the experience gained in performing the exercises suggested here will prove valuable in this direction.

Bibliography

Color

Birren, Faber, *New Horizons in Color,* Reinhold Publishing Corp., New York, 1955.

Burris-Meyer, Elizabeth, *Color and Design in the Decorative Arts,* Prentice-Hall, Inc., New York, 1940.

Bustanoby, J. H., *Principles of Color and Color Mixing,* McGraw-Hill Book Co., New York, 1947.

Chevreul, M. E., *The Principles of Harmony and Contrast of Colours,* Bell & Daldy, London, 1870.

Crewdson, Frederick M., *Color in Decoration and Design,* Frederick J. Drake & Co., Chicago, Illinois, 1953.

Evans, Ralph M., *An Introduction to Color,* John Wiley & Sons, Inc., New York, 1948.

Graves, Maitland, *Color Fundamentals,* Mc Graw-Hill Book Co., New York, 1952.

Jacobson, Egbert, *Basic Color,* Paul Theobald, Chicago, 1948.

Judd, Deane B., *Color in Business, Science and Industry,* John Wiley & Sons, Inc., New York, 1952.

Ladd-Franklin, Christine, *Colour and Colour Theories,* Harcourt, Brace & Co., New York, 1929.

Land, Edwin H., "Experiments in Color Vision," *Scientific American,* May, 1959.

Luckiesh, Matthew, *Color and Its Applications,* D. Van Nostrand Co., Inc., New York, 1921.

Luckiesh, Matthew, *Color and Colors,* D. Van Nostrand Co., Inc., New York, 1938.

Maerz, A., and Paul, M. R., *A Dictionary of Color,* McGraw-Hill Book Co., New York, 1930.

Munsell, Albert H., *A Color Notation,* Munsell Color Co., Inc., Baltimore, 1936.

Sargent, Walter, *The Enjoyment and Use of Color,* Charles Scribner's Sons, New York, 1923.

Science of Color, prepared by Committee on Colorimetry, Optical Society of America, Thomas Y. Crowell Company, New York, 1953.

Painting Materials and Techniques

Doerner, Max, *The Materials of the Artist and Their Use in Painting,* Harcourt, Brace & Co., New York, 1949.

Farnsworth, Jerry, *Learning to Paint in Oil,* Watson-Guptill Publications, New York, 1957.

Gasser, Henry, *Techniques of Painting,* Reinhold Publishing Corp., New York, 1958.

Getlar-Smith, Jacob, *Watercolor Painting for*

the Beginner, Watson-Guptill Publications, New York, 1957.

Gettens, Rutherford J., and Stout, George L., *Painting Materials, A Short Encyclopaedia,* D. Van Nostrand Co., Inc., New York, 1942.

Guptill, Arthur L., *Oil Painting Step-by-Step,* Watson-Guptill Publications, New York, 1953.

Guptill, Arthur L., *Watercolor Painting Step-by-Step,* Watson-Guptill Publications, New York, 1957.

Haines, F. Merlin, *Tone and Color in Landscape Painting,* Pitman Publishing Corp., New York, 1955.

Hiler, Hilaire, *Notes on the Technique of Painting,* The Exposition Press, Inc., New York, 1955.

Kautzky, Ted, *Ways with Watercolor,* Reinhold Publishing Corp., New York, 1949.

Lintott, E. Bernard, *The Art of Water Colour Painting,* Chapman & Hall, Ltd., London, 1926.

Mayer, Ralph, *The Artist's Handbook of Materials and Techniques,* The Viking Press, Inc., New York, 1957.

Mayer, Ralph, *The Painter's Craft,* D. Van Nostrand Co., Inc., New York, 1948.

Olsen, Herb, *Watercolor Made Easy,* Reinhold Publishing Corp., New York, 1355.

Richmond, Leonard, *The Technique of Colour Mixing,* Pitman Publishing Corp., New York, 1949.

Schmid, Frederic, *The Practice of Painting,* Faber and Faber, London, 1948.

Taubes, Frederic, *Oil Painting for the Beginner,* Watson-Guptill Publications, New York, 1945.

Taubes, Frederic, *Oil and Tempera Painting: 500 Questions and Answers,* Watson-Guptill Publications, New York, 1957.